CHURCHES OF KENT

JOHN E. VIGAR

AMBERLEY

This edition first published 2022

Amberley Publishing
The Hill, Stroud
Gloucestershire GL5 4EP

www.amberley-books.com

British Library Cataloguing in Publication Data.
A catalogue record for this book is available from the British Library.

ISBN 978 1 3981 0526 3 (print)
ISBN 978 1 3981 0527 0 (ebook)

Typesetting by SJmagic DESIGN SERVICES, India.
Printed in Great Britain.

CONTENTS

INTRODUCTION

If you were to stand on one of Kent's vantage points to admire the view it would always include churches. Then if you were to start to strip away the more recent developments of factories, motorways, mansions eventually, apart from a few Roman roads and walls, all you would be left with were the churches. They are the most numerous survivals from the earliest age of building and are a tangible link with our ancestors.

However, Kent has a Christian heritage older than church buildings, as the faith first came with the Romans, as evidenced by iconography at Lullingstone Roman Villa, and in the Saxon 'Darenth Bowl' in Dartford Museum which shows that Christianity survived the departure of the Romans. The story then builds with the writings of Bede who records the arrival of Bertha in the late sixth century followed shortly by St Augustine and his followers. This is when church buildings as we recognise them today first appear. St Martin's Church in Canterbury is the oldest church in England still in use, with at least one wall surviving from Bertha's place of worship. Bertha's husband, King Ethelbert, and their children converted to Christianity and established churches across east Kent which acted as bases for further evangelisation. Whilst most surviving work of this early period is relatively simple, it may still be seen in several Kent churches including Lydd, Lyminge, and Minster in Sheppey.

Early, too, are Kent's cathedrals founded within eight years of each other, immediately after Augustine's arrival. Both have been rebuilt and beautified over the centuries as the mother church of their respective dioceses, but sadly they remain outside the scope of this book.

By the time of the Norman Conquest in 1066 Kent could boast several dozen parish churches, but this number was increased dramatically under the invaders, who used churches to stamp their authority on the country. Technically in Kent they were settlers, not invaders, as the county motto 'Invicta' reminds us, but nevertheless their church building and replacement strategy was the same across the country. Many outstanding buildings of this period survive and are characterised by strong, thick-walled constructions and the use of repetitive geometrical designs.

In many ways it was the thirteenth century that marked the high point of church design in Kent. The pointed, Gothic arch was adopted as the standard form, which allowed large glass-filled windows to replace their smaller round-headed predecessors. More money was available from private benefactions and from agriculture, whilst changes in liturgy called for alterations to existing buildings. Outstanding amongst Kent churches of this period is Stone next Dartford, though even the simplest of churches usually includes work of this date.

The fourteenth and fifteenth centuries are also well represented, though this depended much on the wealth, or otherwise, of individual places after the Black Death in 1348. Some communities never recovered and began a centuries-long decline; others did so quickly as a result of industrialisation and their churches bear witness to their newfound prosperity.

By the time of the Reformation Kent had all the churches it needed – in fact it had too many – and few new ones were built for the next 250 years. A notable exception was in the new settlement of Tunbridge Wells where a place of worship was required for visitors to the spa. Even so it did not legally become a parish church until the nineteenth century. During the eighteenth century many churches were reseated and a surprisingly large number of examples survive with box pews and three-decker pulpits. The nineteenth century saw many churches repaired after years of neglect together with the construction of new churches, either to replace those that were too far gone, or to serve new communities. Rarely outstanding they do, however, help us understand the fashions of the day and remind us of the enormous contribution religious philanthropists played in Victorian society.

I am often told that 'churches are always locked these days'. In fact, there are now more churches open than ever before. At least half of parish churches in Kent are open to visitors every day and those that aren't usually have a notice telling you where to go for the key. The main insurers of churches tell us that open churches have far fewer claims than churches that are locked – where people cause damage breaking in just in the hope that there is something of value to steal. Religious buildings are amongst our finest museums, with art that any national collection would be proud to display. They are available to us all, regardless of religious belief, and their true benefit to the general population, as a source of historical research, is still largely untapped.

In a book which covers just fifty buildings it is inevitable that some popular churches will have been omitted. However, in their place I hope you will discover some little-known gems that I've discovered in more than fifty years of 'church crawling' in the county.

ADISHAM, HOLY INNOCENTS

Churches were costly and labour-intensive buildings to construct, especially where the local building material was flint. Its uneven, nodular character makes the construction of corners difficult, often requiring that better-quality stone must be brought from elsewhere. Here the church is nestled slightly below the hilltop to give it some protection from the elements, whilst still allowing it to dominate its location. Dating in the main from the thirteenth century, its very distinct character is given by tall lancet windows which on the exterior are bereft of hoodmoulds. These are the 'eyebrows' we expect to find over church windows, and which are designed to channel water away from the expensive glass below. This shows that Adisham church was built just before such a feature became commonplace, although a slightly later window in the south wall of the nave shows us what a difference these make to the overall character. The church is distinguished too by having a central tower – this shouts wealth and, indeed, it was in the patronage of Canterbury Cathedral, whose monks saw the building of churches in its care as

good PR for their work. Inside, all is calm and simple, except for an extremely rare screen dating from AD 1200. This didn't originate in Adisham and probably came from Canterbury Cathedral in relatively modern times. It is unusual to find any church furniture of this date in a parish church, even more so in this unfrequented part of Kent.

ALKHAM, ST ANTHONY THE MARTYR

East Kent is full of high-quality thirteenth-century work but here at Alkham the bar is raised considerably. The church is long and ground-hugging and built of local flint. Ignore the first impressions given by the large later windows, for here is an early thirteenth-century church whose patron, St Radegund's Abbey, was determined to show its wealth and local influence through architecture. Just under the roofline you can see a row of round clerestory windows. These allowed light into the nave which had been made much wider than usual by the addition of aisles, of which the southern one survives. Later, clerestories were to become huge status symbols but here they are in their infancy, and purely functional. It is probable at this time that they didn't even contain glass.

Once inside you can see that the north aisle has been demolished to make way for the best feature of the church, a north chapel of extraordinary length. This is distinguished by blank arcading that runs along its north wall – a series of arches separated by Purbeck marble shafts. These were purely decorative, the arches themselves possibly designed to frame wall paintings. The contrast between the dark Purbeck marble and the white-painted arches above is typical of the

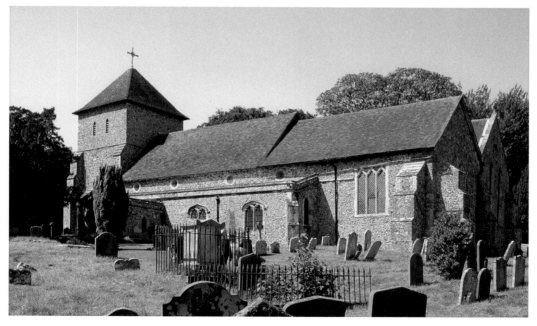

Alkham. Exterior from the southeast showing the round clerestory windows and long, low profile of the building. (Photo by John Salmon)

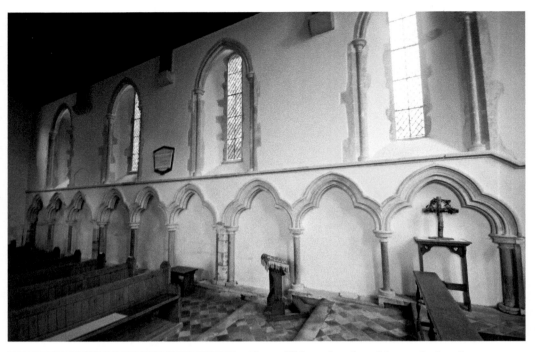

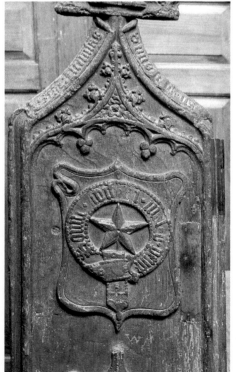

Above: Alkham. Interior of the north chapel depicting the blank wall arcading of the thirteenth-century and characteristic horizontal roll moulding above. (Photo by Ian Hadingham)

Left: Badlesmere. One of the medieval bench ends depicting the star emblem of the Earl of Oxford, encircled by his Garter motto. (Photo by John Salmon)

Badlesmere. Surviving Georgian glass in typical orange and lilac shades in the tracery of a nave window. (Photo by John Salmon)

thirteenth century when designers were playing with dimensions. They tried in the east wall too where two tall lancet windows are set off by not one, but two sets of Purbeck marble shafts. Beneath them two corbels project from the walls and must once have supported tall statues. Also in this chapel is a rare tomb slab with an early inscription: '*Here lieth Herbert, offspring of Simon, a man openhearted, assured by hope of good things, fluent in the word of faith*'. That this is still readable 700 years later is quite remarkable.

The church contains two good stained-glass windows. The east window is by James Powell and Sons of 1902 and shows scenes relating to The Resurrection. The other, by Caldwell of Canterbury, dates from 1954 and shows St Mary and St John the Evangelist.

BADLESMERE, ST LEONARD

If ever a church deserved to be better known, this is it. Overshadowed by its grand neighbour at Faversham, this is a true Kent country church, unpretentious and looking as if it has grown from its surroundings. It is a two-cell construction, that is, of nave and chancel only with minimal structural delineation between the two inside. The exterior character is mostly the result of nineteenth- and twentieth-century 'patching up', but there are still clues to be seen. In the north wall of the chancel one can see the vertical line that once marked the easternmost wall of the

chancel before it was enlarged to allow for a more elaborate ceremonial in the early thirteenth century.

The interior is an idiosyncratic mixture of things rarely found together in one building. The nave has a set of box pews and a two-decker pulpit dating from the eighteenth century. Bizarrely set into them near the altar rails are two extremely fine medieval bench ends – a rarity indeed in Kent. One is carved with the well-known emblem of the Trinity as a shield containing three arms. The other depicts the arms of the Earl of Oxford, Lord of the Manor here in the fifteenth century. Behind the altar are the Lord's Prayer, Ten Commandments and Creed displayed as they would have been in all churches in the eighteenth century, whilst in front of them is a tiny wooden Holy Table. Before the wholesale reordering of churches in the nineteenth century with an increased emphasis on the altar, this is just the size that would have been universal. Another rare survival is the coloured glass in the tracery of one of the windows. The orange and purples with dainty floral quarries are typical of the Georgian period before we brought back the art of pictorial stained glass. A more modern window by F. W. Cole depicts Badlesmere church in the background to the story of The Sower. At the west end of the church are the royal arms of King George I dated 1717. Look out for the white horse of Hanover in the bottom right-hand corner. It is possible to see the joins in the wooden panels on which they are painted. Later royal arms are usually painted on canvas. Also painted on boards are the simple framed Text Boards admonishing us in true eighteenth-century style, though they are often missed by the visitor who looks upwards to the fourteenth-century crownpost roof.

BARFRESTONE, ST NICHOLAS

Undoubtedly in the top ten Kent churches, Barfrestone is still a remote and quiet place. Built late in the Norman period, around 1180, it uses a high proportion of Caen stone, imported from Normandy. Even though it is relatively near the coast this would have been a mammoth effort and expense. The reason for this extravagance is that someone wanted to make a statement with a church that was elaborately carved – and this would have been impossible with any local English stone. Who that person was we have few clues, but his legacy to us is a sumptuous exterior with few parallels.

The church is two-cell in plan and built into a hillside that slopes steeply down to the east. Two arches under the east wheel window go some way to stopping it sliding downhill, but this end of the church was taken down and rebuilt exactly as it had been in 1840. Above the lower stage of the wall, which is undecorated and made of local flint, is an ashlar course of Caen stone which is carved with a series of round-headed arcades. Some are pierced as windows; others have always been blank. Above them, supporting the roof is a corbel-table, a row of sculptured heads, mainly of beasts. Medieval belief was that evil spirits hid everywhere to catch us unawares and these monsters were carved to stop them hiding under the eaves of the church. The Caen stone is very soft and does not weather well but you can tell what most of the figures depict.

The outstanding survival is the south doorway which always reminds me of a wedding cake, so delicate are the carvings. The main subject is Christ in Majesty,

seated in a mandorla with his hand raised in blessing. He is surrounded by angels and a couple who may be a king and queen. Around them are a series of musicians including a very early depiction of a harp played by a fox (left of Christ), whilst the larger figures surrounding them depict the Labours of the Months. Don't miss the little knight in the bottom left-hand corner with his 'Noggin the Nog' appearance! Whilst the blocked north doorway is nothing in comparison to that on the south, it is a fine piece of art with an amazing monster carved on the capitals. Fine, too, is the great wheel window at the east end with column-swallowing monsters devouring each spoke, but closer inspection reveals that a lot of its carving is a replacement. After all the external excitement the interior seems rather plain but there is much original carving here too. My favourite is on the frieze which runs around the walls and shows a monkey and a donkey cooking a rabbit!

Barfrestone.
South doorway of
mid-twelfth-century date
carved in imported Caen
stone. (Photo by John
Salmon)

Above: Barfrestone. Exterior from the northeast showing lower walls of flint, eastern buttresses to stop the church sliding down the slope and corbel table of carved heads around the walls. (Photo by John Salmon)

Left: Boxley. Carved head on corbel depicting a bridled woman. (Photo by John Salmon)

Boxley. *The Adoration of the Magi* in opus sectile work by Powell's. (Photo by John Salmon)

BOXLEY, ST MARY AND ALL SAINTS

Boxley is one of a string of villages in Mid Kent that sit along the spring-line on the southern slopes of the North Downs. Each is nestled below the old trackway now known as the Pilgrims Way which, of course, ran above the spring-line for practical reasons. Around a mile away stood an important monastery, Boxley Abbey, and it was very successful in attracting pilgrims from the track above to visit it. Boxley church wanted some of the action and records suggest the present tower was rebuilt in the fifteenth century to make the church more obvious from above in the hope of attraction visiting pilgrims with their generous donations! In most places that had a Norman two-cell church later adaptations meant that they were enlarged and brought up to date in a way which left them almost unrecognisable.

Here at Boxley in the thirteenth century the decision was taken to build a completely new church to the east of the existing one, joined to it, rather than trying to enlarge the original. This gives us a unique opportunity to compare the two side by side. We enter the church through what was originally the nave of the Norman church which now acts as a huge porch. Its north wall shows two pointed arches which would once have led into a north aisle. Outside on its south wall is a fragmentary thirteenth-century blocked window. Then we pass into what would have been its chancel, but which became the base of the new tower. It is only then that we find ourselves in a complete late thirteenth/early fourteenth-century church! For the uninitiated it is a complete shock – so you would be advised to walk around the outside of the church first so that you can get your bearings! The outer walls are built almost entirely from ragstone quarried just a few miles away, although the way in which it was used in the two building campaigns varies considerably.

Inside the main church the arcades are formed of circular piers constructed not of ragstone but of expensive sandstone from the royal quarries at Reigate, Surrey. To the south of the chancel arch is a hagioscope – a hole cut through the wall to allow a priest saying mass at an altar at the east end of the south aisle to see the priest saying mass at the main altar. These are a common feature of our medieval churches but have found themselves caught up in the mythology of nineteenth-century fantasy when historians had little idea of how medieval churches worked. Another such fantasy may also be clearly seen here if you stand at the extreme west end of the 'new' church and look towards to the altar. It is obvious that the centre line down the church is not straight. It veers to the right before it reaches the altar. Our Victorian predecessors assumed that this was deliberate, to signify Christ's head on the cross, but we now realise that it is a building error caused by the builders desperately trying to align the church due east and only having the sun to help their calculations. The chancel was significantly refurnished in the nineteenth century when the two huge Opus Sectile panels of the Nativity and Adoration of the Magi were installed by James Powell and Sons to either side of the east window.

Elsewhere in the church there are some monuments with interesting inscriptions, including one to William Alexander, the late eighteenth-century artist who is best known for his engravings of China made in 1792. The corbels supporting the wall

posts of the crownpost roof have some amusing faces carved on them including a bridled woman.

BROOKLAND, ST AUGUSTINE

The Romney Marshes are without parallel for their interesting churches. Each one is both characterful and informative and it is difficult to pick just a handful for this small book. However, there can be no escape from the fact that Brookland is many peoples' favourite. It stands at the centre of its small village and has two unusual offerings. Firstly, it has an enormous porch with stable doors and, perhaps most famously, its free-standing bell tower. This takes the form of a giant candle snuffer climbing in three diminishing stages to an accusatory point. Local legend tells that it was once the spire of a conventional stone tower but when an old spinster and confirmed bachelor came to the church to be married, it fell off in surprise! Reality is rather more interesting. If you visit the nearby churches of Snargate and Newchurch you will see the trouble they had in keeping their towers upright on the reclaimed ground. The folk of Brookland were more sanguine and housed their bells in a ground-floor cage, later heightened to the present structure, that would spread the weight and move with the stresses of ringing bells. Although only open occasionally, its interior is a forest of timbers brought from the Kentish mainland.

The church itself is unlike any other in Kent. It is much longer and wider than you might expect as you see it from the road, and its leaning arcades prove that here we are on shaky foundations indeed! The oldest part of the present building is the chancel with its clean simple lines and lancet windows of the thirteenth century. The nave was rebuilt a hundred years later, as the octagonal piers of the arcade show. It is possible to judge just how much movement there has been in the walls by looking up at the crownpost roof, the tie beams of which (the horizontal timbers that support the weight of the roof on the walls) are now too short to support the roof, and which have had to be crudely extended. The floor, too, goes this way and that and is just as most country churches would have looked before nineteenth-century restoration.

Opposite the door is one of Kent's greatest treasures, a lead font. One of fewer than three dozen in England, its bold design and complex iconography draw visitors by the coachload. It was cast in France in the twelfth century in a mould that might have produced numerous identical copies. If it did, this is the only one to survive. In addition to its decorative rim there are two series of narrative pictures. The topmost shows the Signs of the Zodiac. Below them, set within a second arcaded frieze, are the corresponding Labours of the Months. To some visitors it seems odd that such prominence should be given to secular subjects, but the medieval labourer was tied to agriculture which in turn was governed by the stars, making this as important a part of life as religion itself.

As if this font was not enough, Brookland church just keeps giving. At the end of the south aisle is an important fragment of wall painting depicting the murder of Thomas Becket at Canterbury. Most of these marshes were reclaimed by Canterbury's monastic houses, so the cult of St Thomas was particularly strong in this part of Kent. Beneath the painting is a more recent treasure, a communion rail from the eighteenth century with closely set balusters and a gorgeous,

tactile curve. It's not in the original position, but nonetheless is a rare survival from an age when everything introduced to a parish church was craftsman made. Close by is a piscina, the drain for the priest to wash his fingers before mass, with charming medieval floral decoration which reminds us that few flat surfaces were left undecorated in the medieval church.

On the north side of the church, hidden by the organ and so missed my many visitors, are remains of fourteenth-century glass still in its original window. With so little stained glass on the Romney Marshes this is worth seeking out. The church is stuffed full of box pews dating from the eighteenth century. They gave protection from draughts and privacy to those able to afford the rent. Those who couldn't sat on simple benches down the middle of the church. In our own time box pews have provided a haven for bored boys who whiled away the service by drawing boats in pencil inside them – the best examples can be found next to the porch!

As way of a final *douceur* to visit Brookland, in the churchyard very close to the south wall of the church is a headstone within which is set a Harmer plaque. These late eighteenth- and early nineteenth-century terracotta ovals are a feature in neighbouring Sussex, and this is one of only two in Kent. It depicts a basket of fruit with its makers' mark '*Harmer, Fecit*'.

CANTERBURY, ST MARTIN

Many of the thousands of visitors to Canterbury who come to see the spiritual home of the Anglican church are unaware of this, arguably more important, site just a short walk from the city walls. According to Bede's *Ecclesiastical History*, it was here that Augustine found Queen Bertha worshipping in her own church when he arrived in Kent in AD 597. Our problems stem from how to interpret this information. Had Bertha built her own church here after marrying King Ethelbert in the 580s, or had she adapted an existing building? The latter theory is supported by the fact that here we are outside the city, in the sort of location that roman settlers often used as cemeteries, so this may have started as a building associated with a cemetery during the later Roman period. If so, it takes the surviving piece of wall still to be seen at St Martin's back a further 150 years at least. The wall in question is now just the western end of the south wall of the chancel, but it is a tangible link with our Roman and Saxon predecessors.

The church is built of large quantities of Roman tile mixed with local flint and ragstone. The exterior shows typical Saxon buttresses and long and short work at the quoins, but there are no Saxon window openings still in use. However, the west wall inside has been stripped of plaster, which allows us to easily see blocked Saxon windows. Apart from the great age of the walls there is little of visual interest – with a fourteenth-century tower at the west end and a rather severe atmosphere resulting from the drastic nineteenth-century restoration that saw the insertion of much-dark stained glass. Were it not for the early history of this church the font would be its outstanding feature. It is of Norman date and is carved from a large block of Caen stone. Tall, solid, and eminently decorative, it has intersecting circlets in two lower levels, and arcading of Romanesque arches above, topped by a rim of rolling swags. As a complete contrast to these early treasures the churchyard contains the grave of Mary Tourtel, creator of Rupert Bear.

Capel, St Thomas of Canterbury

Although just a few miles from the conurbations of Tonbridge and Tunbridge Wells we are still in the heart of the countryside at this charming church which has extensive views from its churchyard northwards towards the Greensand Ridge. The local building stone here is a honey-coloured sandstone which is easy to carve. First impressions are of an ancient site, the church protected by huge yew trees, but it is clear also that there has been much rebuilding, for the south wall looks rather too well-preserved to be old. The reason for this is that the church was damaged in a seventeenth-century storm, the tower was completely rebuilt, and the south wall patched up only to be rebuilt completely just before the First World War.

Entrance to the church is under the tower into a very simple two-cell interior, the nave having a crownpost roof supported on surprisingly low wooden braces. The north wall is what we have come to see as it survives intact from the Norman period and carries significant remains of thirteenth-century wall paintings. These were limewashed over at the Reformation and only rediscovered in 1927. Like much early decoration they were conceived as two individual schemes divided horizontally. By the font is a niche with fictive curtains pulled up around its upper edge. Immediately above this is a horizontal band of paint, above which is the upper scheme. Of note in the less-damaged lower scheme is Christ's Entry into Jerusalem and the Last Supper. Between these scenes is a Norman window opening and in its splay is a further painting showing Cain killing Abel. Also admire the lovely east window of Christ, King of Glory by H. W. Lonsdale (1905), the communion rails dated 1682, and the Georgian royal arms creed and Ten Commandments now displayed over the west door.

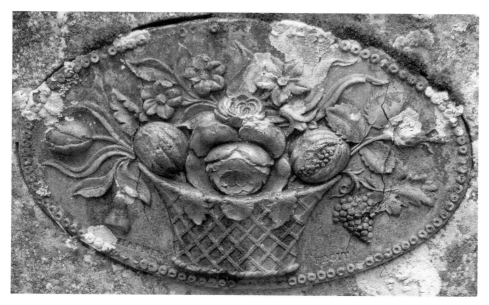

Brookland. Terracotta Harmer plaque on a headstone in the churchyard. (Photo by John Vigar)

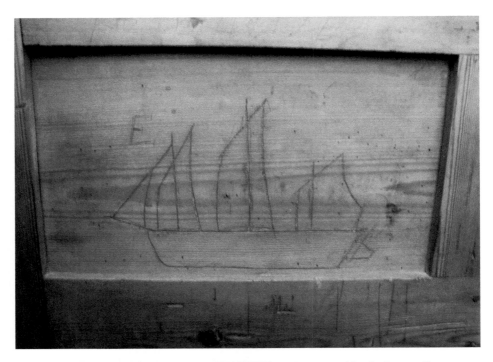

Above: Brookland. Ship graffiti in a box pew. (Photo by John Vigar)

Left: Canterbury, St Martin. Surviving wall of Queen Bertha's church. (Photo by Ian Hadingham)

Canterbury, St Martin. West wall of the church showing the 'vertical archaeology' with blocked Saxon windows. (Photo by Ian Hadingham)

CHALLOCK, ST COSMOS AND ST DAMIAN

One of the most remote churches in the county, it is dedicated to two third-century Syrian physicians. The isolated location of the church is down to two factors. Originally there was a settlement here but the closing off of the road leading to Ashford for the creation of Eastwell Park and the building of a turnpike road from the top of Charing Hill to Chilham combined to influence the growth of a new village, Challock Lees, in a more convenient location. It is ironic that this most isolated church received a direct hit in the Second World War, but this disaster was turned to advantage when the church was rebuilt. It is constructed of flint rubble and displays an interesting inset flint cross (one of three in Kent) on the west face of the tower.

There is little stained glass in the church, but it does contain an even more important example of decorative arts. In the 1950s two art students painted a series of murals in the north chapel to show stories from the lives of the patron saints. The figures are dumpy and stylised and altogether great fun! At the same time the chancel walls were painted by John Ward RA with scenes from the Life of Christ. These are more naturalistic and include portraits of local people in modern costume. Later he returned to add paintings in the north aisle which depicted modern-day life in the village at the turn of the Millennium. One other furnishing of note survives – a prickett beam in the north chapel which was erected in the fourteenth century to display votive candles and a veil to hide the altar from view during Lent.

CLIFFE, ST HELEN

If churches were sweets, St Helen's would be an Everton Mint! Its unmistakeable exterior is a veritable confection of dark local flint alternating with Kentish ragstone and there's no missing the church on the escarpment that looks down to the River Thames. This extraordinary fashion statement is to be seen in more restrained forms in other north Kent churches but here it reflects the patronage of the church under the Prior of Canterbury Cathedral. Dating in the main from the thirteenth century, were it not for its remote location, this would be one of the most famous churches in the county.

If the exterior promises much, the interior lives up to it. This is an enormous church, full of interest. Firstly, the piers of the nave retain a lot of their decorative scheme of chevron painting. In the chancel the sedilia, or seats for clergy, date from a rebuilding early in the fourteenth century, whilst opposite is a fine canopied tomb recess of roughly the same date. Both transepts have the remains of large-scale wall paintings, although they have been badly treated in the past. The base of the rood screen is fifteenth century while the rather insubstantial traceried top is an early twentieth-century addition. There is an elaborate tie-beam high in the roof with little quatrefoil piercings in the spandrels, but this could not have supported the rood as the remains of the rood loft staircase may be seen in its usual position. Outside the north chancel wall a piscina and holy water stoup can be found – all that remains of a medieval chantry chapel or anchorite's cell which has been demolished. The blocked-up doorway that originally gave access to it may be seen both inside and out.

Capel next Tonbridge. Exterior from the southwest showing the rebuilt tower and twentieth-century south wall. (Photo by Simon Knott)

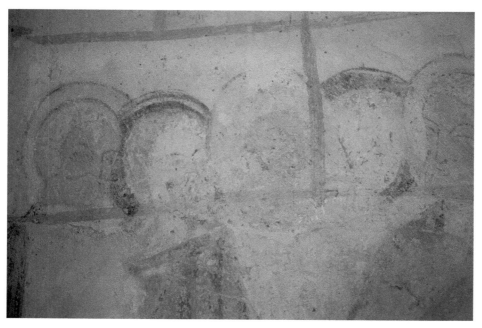

Capel next Tonbridge. Detail of medieval wall painting depicting the Last Supper. (Photo John Vigar)

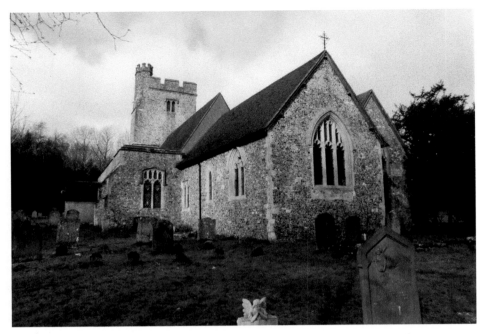

Challock. Exterior from the east showing flint rubble construction. (Photo by John Vigar)

Challock. A scene from the Millennium mural by John Ward RA. (Photo by John Vigar)

COBHAM, ST MARY MAGDALENE

If ever a church owed its fame to one family it is this one, its history closely entwined with the eponymous family who were Lords of the Manor throughout the late medieval period. Whilst the village is probably more associated with Charles Dickens, who liked popping out here for an ale or two, most visitors following in his footsteps will visit the church to see the brasses to the extended de Cobham family, medieval wheelers and dealers, whose monumental brasses literally cover the floor of the chancel. It is a display like no other and is said to form the largest collection of medieval brasses in existence. The first thing we should note is that they have been re-arranged, but this in no way detracts from the importance of the sixteen slabs of stone each inset with an effigy of the deceased. Brasses first make their appearance in the late thirteenth century and are made of an alloy called latten, which is made from copper and tin. A general rule of thumb is that the larger they are, the earlier, and these are mostly fourteenth and fifteenth century in date. The most important is easily spotted. It is Sir John de Cobham who died in 1408 and you can find him by looking for a man holding a church. Sir John took this parish church at Cobham and re-established it as a collegiate foundation where a college or house of priests would live to pray for the souls of himself and other benefactors. Easily missed by many visitors is the house where these clergy lived, which is to be found around the other side of the church from the street. It is open to visitors. Also in the chancel, erected at a time when brasses were going out of fashion, is the table tomb of Sir George Brooke, 9th Lord Cobham who died in 1560. It is carved in different coloured alabasters with applied paint and demonstrates the move from Gothic to classical design. I especially enjoy the complex heraldry that proved Brooke to be a true descendant of the de Cobham family, and the figures of his named ten sons and four daughters patiently waiting on their parents along each side of the monument. Lord Cobham was a prominent Tudor courtier, cousin of Anne Boleyn and a Knight of the Garter. No wonder he chose to be remembered in such an ostentatious fashion.

COOLING, ST JAMES

One of the county's retired churches, in the care of the Churches Conservation Trust, it was here that Charles Dickens set the opening scene of *Great Expectations* where the escaped convict Magwitch encounters the young Pip as he is looking at his family graves. In reality the graves are those of a local family, the Comports, who sadly lost many children to dengue fever in the early nineteenth century. The grave markers take the form of body stones – tapering blocks of Portland limestone which were a local favourite in the Georgian period. There are thirteen in total, together with a single headstone recording the sad details of birth and death.

The church has a simple plan, but it contains a few surprises. At the back is a set of benches dating back to the fourteenth century. Seats of this date are extremely rare in Kent where most were replaced in the seventeenth and eighteenth centuries. Like many churches, Cooling was given a new tiled floor by the Victorians but under the pulpit is a little hatch that opens to reveal its eighteenth-century

predecessor! The chancel is quite unexpected as it was rebuilt in the thirteenth century with elaborate blank wall arcading as a purely architectural feature, making a contrast to the plain nave. To its south is the vestry whose internal walls have been covered with thousands of seashells. It feels rather like a grotto and reflects the whim of an early nineteenth-century churchwarden. I wonder if Charles Dickens ever saw it?

CRANBROOK, ST DUNSTAN

Cranbrook is a busy little country town but go back 500 years and it would have been a hive of industry as it stood at the heart of the Kentish cloth trade. This in turn brought extreme wealth, as evidenced by the great timber-framed houses that still survive and whose owners, concerned that their fortune might count against their future entry into Heaven, lavished money on St Dunstan's Church. This sets it apart from most Kent churches where irregular bursts of income are seen in small-scale architectural development. Here, a wide-ranging rebuilding of a Saxo-Norman church took place in the fourteenth century, and no expense was spared. The south front was always for show with battlemented parapets to both south aisle roof and that of the clerestoried nave behind whilst fourteen Perpendicular Gothic windows present an unparalleled façade. These would originally have contained stained glass commemorating the donors but today only the arms of one set of donors, the Guilford family, survive in the north aisle.

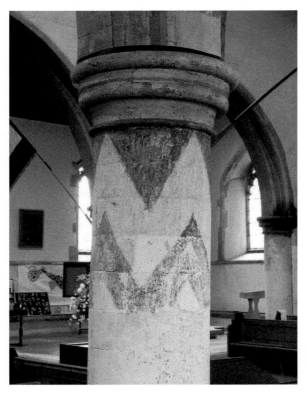

Cliffe. Thirteenth-century chevron design painted on a nave pier. (Photo by John Salmon)

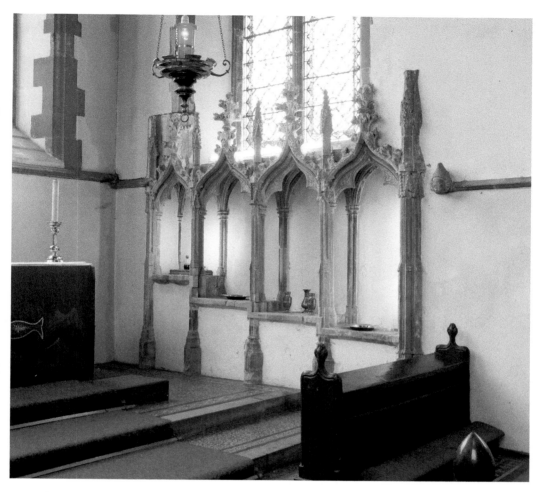

Above: Cliffe.
Fourteenth-century
piscina and sedilia.
(Photo by John Salmon)

Right: Cobham. A floor
completely covered
with medieval memorial
brasses. (Photo by John
Salmon)

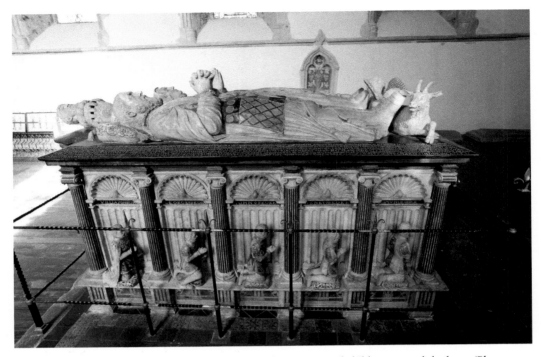

Cobham. Brooke tomb of coloured alabasters showing named children around the base. (Photo by Ian Hadingham)

Inside, either side of the west door are four huge wooden roof bosses, including a remarkable floriate head and between them is a carved royal arms of 1756. Next to the south door is a steep flight of steps leading up to the room over the porch – and this flight of steps hides a secret, for under the platform at the top of the steps is a trapdoor which covers a font for full adult immersion baptism. It was built in 1710 by the then parson, John Johnson, to try to lure attendees away from the nearby Baptist meeting, but it seems only to have been used on one occasion.

Further down the church are the remains of several medieval monuments, especially matrixes – stones in the floor that once displayed monumental brasses. Sadly, most of the brasses have been lost but one particularly relevant one survives and shows the deceased together with his deceased baby and his cloth merchants' mark.

CRUNDALE, ST MARY

What a charming spot this is, high on the Downs, on the edge of a dry valley. It must have always served a scattered farming community and is a humble flint building with one far from humble furnishing. The church is of Norman origin, as can be seen from the surviving window in the north wall of the nave. The semicircular arches of the two-bay arcade are also late Norman, showing that there must have been a benefaction at that time. The aisle is very narrow, which reminds us that aisles were not added to accommodate more seats, but to allow a space for more elaborate processions.

In the eighteenth century the fine reredos with a scrolly pediment and the altar rails were installed. Also in the chancel is a nice single sedile, or seat for a priest, under a carved canopy south of the altar. The stonework of the east window is entirely a nineteenth-century creation, as is the stained glass but in a south chancel window are the remains of medieval glass showing the Coronation of the Virgin. The rood loft stairway survives. The north aisle contains a handsome tomb chest to a priest, John Sprot (d. 1466), in the form of an incised design on an alabaster slab removed here from the chancel. Sprot wears vestments and holds a chalice with the host displayed. His head rests on a pillow decorated with two little *bottonee* crosses. It is a pity that it was not always mounted on a tomb chest as parts of the design have been worn away by the feet of centuries.

DARTFORD, HOLY TRINITY

An old rhyme says 'Dirty Dartford, Proud the people, Bury their dead above the steeple'. Until 1856 this old church was surrounded by a crowded churchyard but in that year a new cemetery was opened on the hill above. Holy Trinity was very much a town church and one which repays close attention.

The north tower is Norman and uses tufa to form the corners. Tufa is a locally sourced material formed in chalk streams, but by the end of the Norman church building period it had all been used up, so if you find it in a church it must be a building of that period, or reusing material from it. The church to which it is attached is thirteenth and fourteenth century, much remodelled by the Victorians. There are two major furnishings to discover. At the east end of the south aisle is a huge and spirited wall painting showing St George, dating from around AD 1500. The architectural details of the castle and distant city are especially delightful. To the north of the chancel is the large tomb of John Spilman, the pioneer industrialist who used his income as jeweller to Queen Elizabeth I to finance the establishment of the first paper mill at Dartford in 1588. The church also contains many other memorials, as befits a civic church, including a series of memorial brasses and some good nineteenth-century stained glass.

DODDINGTON, THE BEHEADING OF ST JOHN THE BAPTIST

This odd dedication is the result of St John the Baptist having several different feast days. This one refers to the original date of his execution in August AD 29. An enchanting Norman church set in a wooded churchyard on the edge of a steep valley, the building displays much of medieval interest due to minimal nineteenth-century interference. The single most important feature is the small stone prayer desk next to the westernmost window of the chancel. This window is of the low side variety – the desk proving the part the window played in devotional activities. It is thought that a clerk followed the service from here and at the Elevation of the Host opened a shutter over the window next to him to create a draught that inflamed the candles on top of the rood screen as a piece of medieval theatre.

The nearby thirteenth-century lancet windows have a series of wall paintings in their splays, whilst opposite is a fine medieval parclose screen complete with canopy over the priests' seats. There is also an excellent example of a thirteenth-century hagioscope that gives a view of the main altar from the south aisle,

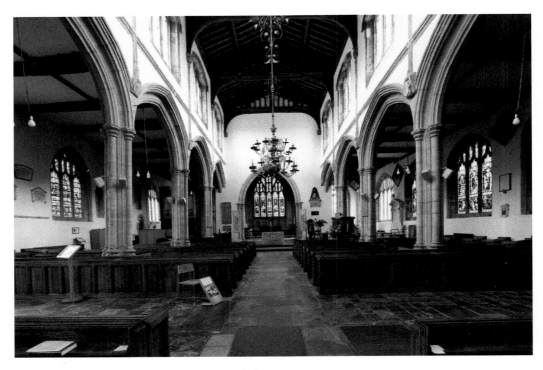

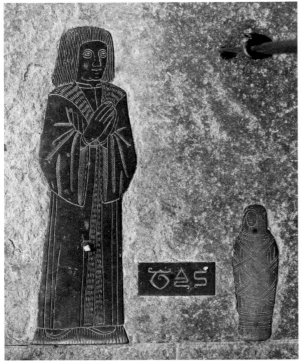

Above: Cranbrook. Interior of the wealthy late medieval rebuild showing characteristically wide aisles and clerestory windows. (Photo by John Salmon)

Left: Cranbrook. Memorial brass with a dead child and a cloth merchant's mark. (Photo by John Salmon)

Opposite above: Crundale. Royal arms of Queen Anne with her personal motto 'Semper Eadem' and date 1710. (Photo by John Salmon)

Opposite below: Crundale. Incised monument to John Sprott. (Photo by John Salmon)

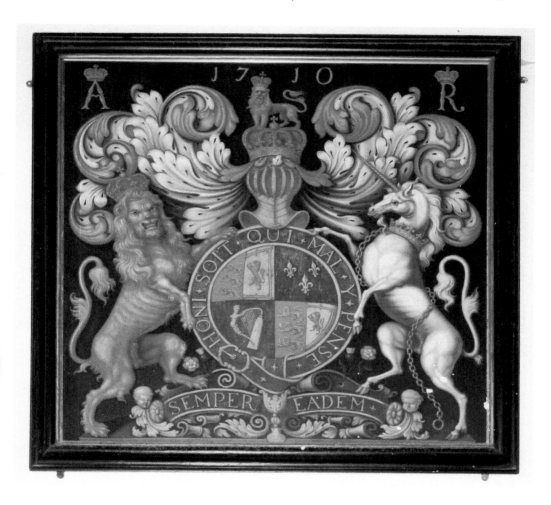

Dartford. Exterior from the southeast with the medieval vestry in the foreground. (Photo by John Salmon)

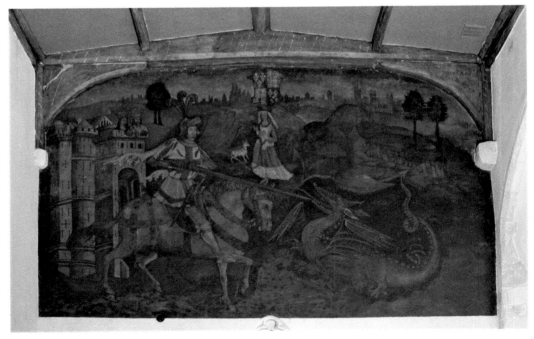

Dartford. Fifteenth-century mural of St George including the royal arms. (Photo by John Salmon)

which was a structural addition to the Norman building. The south chancel chapel belonged to the owners of Sharsted Court and contains a fine series of memorials to them. Most of the stained glass is nineteenth century – some of very good quality indeed, especially the roundel of the Crucifixion by Thomas Baillie (1868). Outside there is a good tufa quoin on the north wall of the nave, proving its Norman origins, and a short weatherboarded tower.

EAST PECKHAM, ST MICHAEL

There can be no finer sited church in the county. On a clear day you can see across to the sandstone ridge on the far side of the wide Medway Valley. The village which this church formerly served is 3 miles away down by the river and now has its own Victorian church, the building of which eventually led to the closure of this church in the twentieth century. Now cared for by the Churches Conservation Trust, St Michael's is open daily.

The south aisle is divided from the nave by a series of thirteenth-century arches, and it is at once obvious that the aisle has been much widened for the arch from the aisle into the south chapel isn't centrally placed. In the centre of the main gangway is a solid iron grave slab with a simple cross set onto it. Kent and East Sussex once had a thriving iron industry, and this is a rare example of it being used for a grave cover in a Kent church. At the east end of the nave are reset ledger stones to the Whetenhall family. One contains an inscription to 'the thrice-unfortunate' Thomas who was widowed three times. In the north wall of the chancel is a small Norman window – the only survival of that period here – whilst the south chapel contains a private enclosure for the occupants of nearby Roydon Hall. Because it was privately owned it didn't get re-floored when the church was restored in the nineteenth century. The large monument is to Roger Twysden (d. 1672), a constitutional historian whose published diaries record details of his experiences during the English Civil War.

EASTCHURCH, ALL SAINTS

The Isle of Sheppey feels like a world apart. Flanked by marshland to the south and a high ridge of hills to the north, it is an open landscape which, at first glance, can have little to hide. Yet its medieval churches are each worthy of a visit, and none more so than Eastchurch, set at the heart of its compact village. Unusually, the previous church was completely rebuilt in 1431 by its patrons, Boxley Abbey, who were determined to make an architectural statement. I particularly like the flint battlements set on ragstone walls – a design technique that makes them stand out.

Once inside you'll find a large, rather severe interior with three outstanding features. Firstly, the rood screen, which is contemporary with the church. It stretches nearly 50 feet across the width of the building and its depressed arches make a change from the more normal pointed designs. The loft has gone, and the modern cresting is a replacement for it. In the chancel, which is linked to the side chapels by hagioscopes, is a fine early seventeenth-century monument to Gabriel Livesey, Sheriff of Kent, and his wife Anne, their faces painted in a most naturalistic way. The inscription is well worth reading, admonishing us to think not of wealth on earth, but rather on that to be found in Heaven.

The third treasure is much more recent and takes the form of a stained-glass window by the artist Karl Parsons. It commemorates Charles Rolls (1877–1910) and Cecil Grace (1880–1910), pioneering aviators who used the flying ground at Eastchurch belonging to the Aero Club of Great Britain. It shows their personal characteristics of Fortitude and Hope.

FAIRFIELD, ST THOMAS A BECKET

Set in the windswept pastures of Walland Marsh, this is one of the most astonishing and picturesque churches in Kent. There has never been a village here, this timber-framed church serving a scattered population of farms and cottages. It is built on an artificial mound just above the flood line, although modern drainage means it is rarely completely cut off as it was in times gone by. Reached by foot on a causeway from the north-west, it is an adventure just to get there, having first collected the key – it is not locked for security, just to make sure the door is kept properly closed to stop the incursion of messy sheep!

The church is entirely timber framed which, in such a wet location, has caused problems over the years, medieval documents revealing its frequently poor condition. In 1912 the church was entirely dismantled and re-erected with new timbers where necessary and a brick cladding created outside. Despite this the ancient feel of the church was preserved, especially so in its eighteenth-century box pews, painted white with black detailing. They are overlooked by a fine three-

Doddington. Exterior from the southeast with the thirteenth-century Sharsted Chapel in the foreground and a timber tower at the west end. (Photo by John Vigar)

Right: Doddington. Stained-glass roundel of the Crucifixion by Thomas Baillie, 1868. (Photo by John Vigar)

Below: East Peckham. Ledgerstone to the 'thrice unfortunate' Thomas Whetenhall. (Photo by John Vigar)

Here Lye Deposited
the Precious Remains of
ANNE ANGLESYE WHETENHALL
Third Wife of the thrice=unfortunat
THOMAS WHETENHALL of this Parish
of East Pekham in the County
of Kent Esq
Daughter of FRANCIS SAVNDERS of
Shankton in Leistershire Esq and
Dame CATHARINE IERNEGAN
in Norfolk

East Peckham. The arch between south aisle and south chapel is off centre as the aisle was much narrower when first built. (Photo by John Vigar)

Eastchurch. Exterior from the south where the prominent castellations are given prominence in flint on the ragstone wall. (Photo by Ian Hadingham)

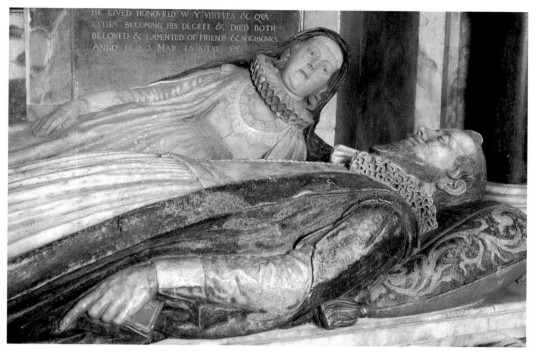

Eastchurch. The Livesey monument, early seventeenth century. (Photo by John Salmon)

decker pulpit – but pity the poor clerk who sat in the lower tier, as his seat offers limited headroom! The fine altar rails, of a type named after Archbishop William Laud who ordered their installation, are earlier, enclosing a square altar on three sides. This was the usual form in the seventeenth century, the close balusters designed to keep dogs from defiling the Holy Table. The Creed, Lord's Prayer and Decalogue cover the wall behind and make the chancel a little claustrophobic. The plain font at the back of the church is rather odd – instead of being the usual octagonal shape it has only seven sides!

FAVERSHAM, ST MARY OF CHARITY

An extraordinary building comprising a medieval chancel and transepts, eighteenth-century nave, tower and openwork spire. Despite heavy-handed restorations of the nineteenth century – by Sir George Gilbert Scott and Ewan Christian in 1873 – which have resulted in loss of patina, there is much to see. The fourteenth-century transepts are aisled – a most unusual feature in an ordinary parish church, and no doubt built to provide chapels to attract pilgrims en route to the neighbouring abbey, which was the burial place of King Stephen. One of the pillars of the north transept has a series of small thirteenth-century paintings of scenes from the Life of Christ. You are advised to take a pair of binoculars to see them to advantage. The stalls in the chancel have misericords with a good selection of carved armrests, and there is also a crypt and an unforgettable east window by A. L. Moore of 1911.

The nave was built in the 1750s to replace a medieval nave and central tower, and this in effect creates a church of two distinct styles. Tall and light, its classical form is in sharp contrast to the medieval work. Since Faversham was always a prosperous port the church contains a large selection of monuments and memorials, the most spectacular being the Easter Sepulchre dating from 1534 to the north of the High Altar. It was started during the lifetime of Lady Joan Norton and finished after her death, but surprisingly she is not buried beneath it. My favourite monument is the mural tablet to Mark Cullen (d. 1679) with his shield of arms, drapes galore and a cheeky winged cherub.

FORDWICH, ST MARY THE VIRGIN
Missed by the tens of thousands of visitors to Canterbury just a short drive away, Fordwich is quintessential England. In fact, it is England's smallest town, established as a quay on the River Stour. The stone that built Canterbury Cathedral was landed here from France and carried by road to complete its journey. St Mary's Church stands in a well-wooded churchyard at the heart of the town, its shingled spire announcing its presence. It has that familiar 'old church smell' and exudes atmosphere. Although no longer regularly used for worship it still feels loved.

The church has a larger than usual collection of furnishings, starting with a full set of box pews, the easternmost of which has a bracket for the Mayoral Mace to be displayed. At the back of the church is a wooden screen that fills in the base of the tower into which are built shelves. These were not for books, as some people think, but for the parish charity to distribute bread to the poor after Sunday worship. Dominating the chancel arch is a huge royal arms of the reign of King William III, in the position most royal arms occupied before the Victorians moved them.

Throwing light into the church are large south windows, and in their tracery are some fine examples of medieval glass that survived the Reformation. Particularly charming is the figure of St Margaret of Antioch trampling on the dragon (take binoculars) and St Mark with his winged lion. These date from the fourteenth century. In the central gangway is a recently conserved brass to Aphra Hawkins (d. 1605) showing her fantastic dress, of which she must have been proud. However, it is an object in the north aisle that attracts most comment, for here is a solid stone shrine of Norman date. Along its front is a series of Romanesque arches, whilst its 'roof' displays fish scale tiles. It is reputed to be part of a shrine of St Augustine brought from Canterbury, having been discovered in an orchard, and is known locally at the 'Fordwich Stone'.

GREAT CHART, ST MARY
In a splendid hilltop location with wide-ranging views east to Ashford and north to the Downs. Passing through the churchyard you cannot miss a minuscule timber-framed building known locally as the Pest House. This is a corruption of Priest House, but the building is too small to live in full time for it was just there to provide overnight accommodation for a travelling chantry priest who visited on a weekly basis to say mass for the soul of its founder.

The interior of the church is rather odd, for the clerestory, or upper row of windows, continues past the chancel arch into the chancel. In this case the division between nave and chancel was the altar side of the chancel arch, rather than underneath it. You can see the blocked staircase to the rood loft stairs in the north wall which would have carried onto the top of the rood screen. It is odd that the arch itself wasn't taken down, or moved, when the chancel was rebuilt, but it explains why the wall above it was removed. At the entrance to the chancel is some delightful seventeenth-century woodwork with pierced traceried panels.

The church boasts quite a collection of hatchments – the Armorial bearings carried at the funeral of the deceased. They all belong to the Toke family of nearby Godinton House, who are well represented with brasses, monuments and tablets covering 400 years. In the south-east chapel are substantial remains of stained glass installed by Bishop Goldwell of Norwich after 1470. He had been born in the parish and this window partly commemorates his parents who are depicted kneeling either side of him, together with their family rebus – a gold well.

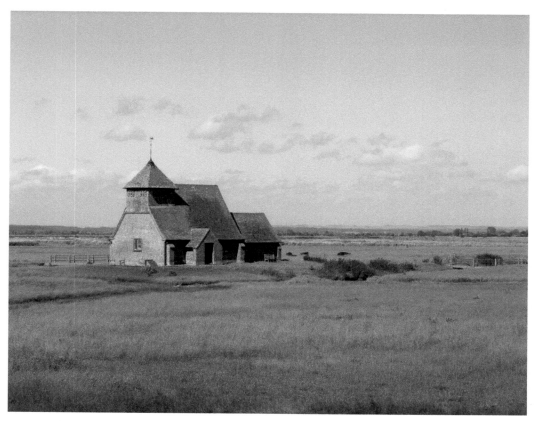

Fairfield. Exterior across the marsh. The church was faithfully rebuilt in the early twentieth century. (Photo by John Vigar)

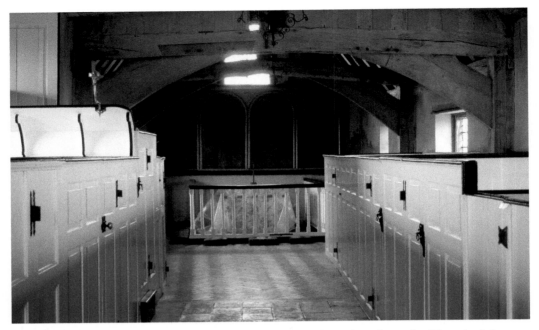

Fairfield. Interior with box pews, three-decker pulpit and Laudian altar rails. (Photo by John Salmon)

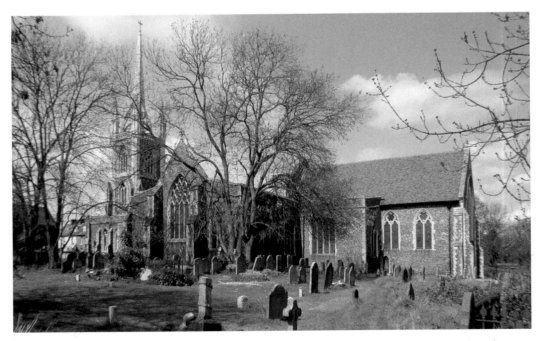

Faversham. Exterior showing the open spire and medieval chancel and transept. (Photo by John Salmon)

Faversham. Interior of the classical Georgian nave with a view to the medieval aisled south transept. (Photo by John Salmon)

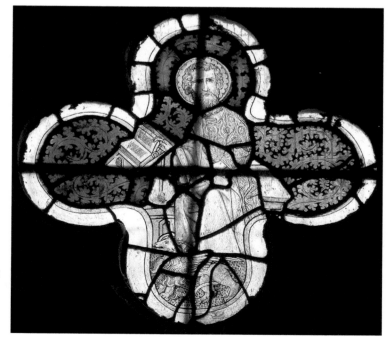

Right: Fordwich. Fourteenth-century stained glass depicting the evangelist St Mark with a lion at his feet. (Photo by John Salmon)

Fordwich. The enigmatic Fordwich Stone which may have formed part of a Romanesque shrine in Canterbury. (Photo by Simon Knott)

HORSMONDEN, ST MARGARET

Before our churches were built populations moved around within an area to suit their farming, for instance having winter and summer grazing lands, or clearing new areas within the Wealden forest. However, once they had embraced Christianity and had built a stone church, that became a fixed point for evermore. Usually it meant they became less mobile and a nuclear village developed. In a few instances later generations preferred to live elsewhere, a village grew up miles from the church and Horsmonden is such an example.

By the churchyard wall is a mounting block that would have been used by those coming to church on horseback. A west tower, nave with aisles and long chancel make this building sound so commonplace yet its atmosphere and furnishings make it stand out as one of the most easily recognisable churches in the county. The chancel has been stripped of its limewash making it an interesting (though historically incorrect) contrast with the plastered and clerestoried nave. There are two rood loft staircases – an obvious sign that over the course of the late Middle Ages the screen changed its position, or access. On the south wall is a memorial bust to an extraordinary inventor, John Read. This nineteenth-century genius invented the round oast-house, the stomach pump and a tobacco enema! Nearby is an early eighteenth-century 'spider' chandelier.

A huge brass is situated in the centre of the chancel (with a rubbing nearby). This is to Henry Grofhurst and dates from the mid-fourteenth century. There are two very colourful windows by Rosemary Everett dating from the 1940s.

HYTHE, ST LEONARD

Although the sea is now a long way off, Hythe was once a major port and a member of the Cinque Ports Confederation, its tightly packed streets and alleyways overshadowed by a church that would not look out of place in France, especially when viewed from the south-east, its towering bulk thrusting from the hillside. Its Norman origins are still to be seen inside, but it is the thirteenth-century style that dominates. This is when the chancel was enlarged and built up so that it rises an impressive twelve steps from the nave, creating a cathedral-like space. It can be dated by the double piscina by the altar. These always date from the end of thirteenth century when the practice was for the priest to wash his fingers in one drain and rinse the chalice in another.

The tall east window is by local stained-glass artist Wallace Wood and depicts the Risen Christ flanked by six colourful angels. In the nave the rather weedy clerestory windows don't bring very much light into the church at all. The pulpit is a bravado piece by George Edmund Street of 1876, appropriately in thirteenth-century character, if not material. The church contains many wall tablets, the most important historically frequently overlooked as it is not architecturally impressive. It is to the Elizabethan mayor, John Collyns, whose inscription tells us all the other offices he held in a remarkably short life. What makes the monument important is that it is one of the earliest signed church monuments in Kent, by the wonderfully named Epiphanius Evesham. His work is also found in other Kent churches, but this is very early and was made before he went to live and work in Paris in 1600.

Under the chancel is a processional passage, open to the public during the summer months. It later became an ossuary and contains the remains of hundreds of parishioners disinterred from the churchyard. It is one of Kent's oldest tourist attractions and has been attracting visitors for over 200 years. In the churchyard is the grave of Lionel Lukin, inventor of the lifeboat who was granted a patent for it in 1785.

IGHTHAM, ST PETER

The further west we move from Maidstone the more we notice a change in building materials. Rather than the grey ragstone of Mid Kent we are now into sandstone territory, a golden, though no better quality, stone. By the churchyard gate is an impressive mounting block which is a reminder of the days when people travelled from distant hamlets to attend church. For such a rural church, St Peter's contains a huge range of interesting monuments. The oldest is to Sir Thomas Cawne, earliest known owner of Ightham Mote, the nearby National Trust house, who died in 1374. His armoured body sits under a canopied arch. His most striking feature is the delicately sculptured chain mail around his neck and under his arms, the work of no provincial artist. At his feet is a lion which represents his courage. The whole effigy is slightly tilted to the south so that he is looking towards the High Altar for his salvation and was a relatively common practice in the Middle Ages.

On the east wall of the chancel is the memorial to Dame Dorothy Selby (d. 1641) who also lived at Ightham Mote. This was designed by the Court sculptor Edward Marshall and shows a white marble Dorothy as an old woman with her long spindly fingers resting on a book. The inscription has been much debated and has been interpreted by some as a reference to the Gunpowder Plot but is more likely to be praising her skills as a needlewoman. In contrast to her high-quality monument, that to her husband and his nephew nearby are rather dull, though on a majestic scale.

Great Chart. Former chancel arch now left isolated when the clerestory windows were added to the church. (Photo by John Vigar)

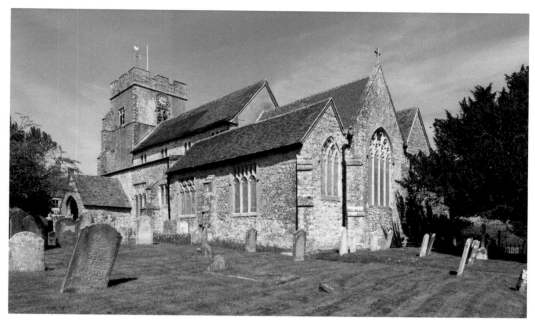

Great Chart. Exterior from the southeast which clearly shows the different roof structures of chancel, chapels, nave and aisles. (Photo by John Vigar)

Horsmonden. Mounting Block of brick to serve those who travelled here by horse or in a carriage. (Photo by John Salmon)

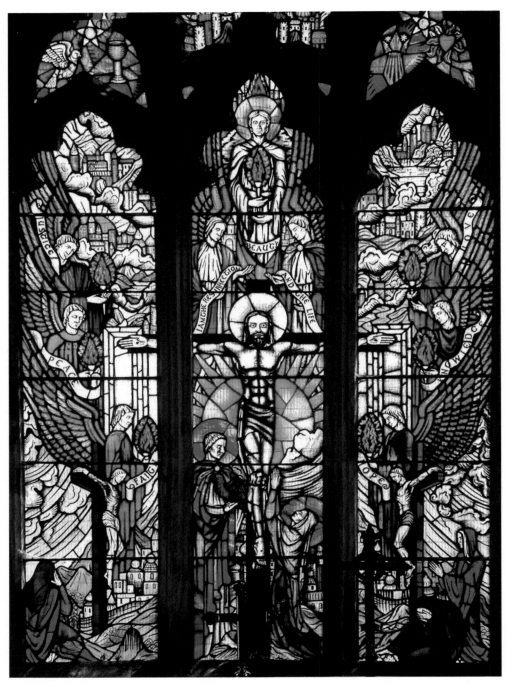

Horsmonden. Striking east window of the Crucifixion by Rosemary Everett, 1946. (Photo by John Salmon)

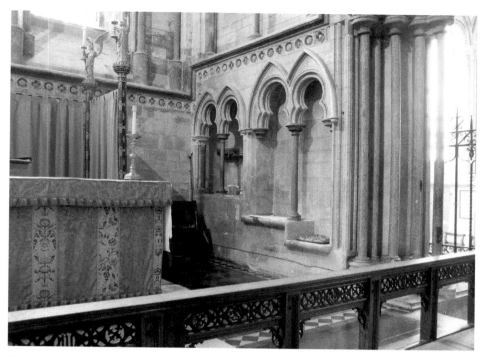

Hythe. Thirteenth-century sedilia and double piscina. (Photo by John Salmon)

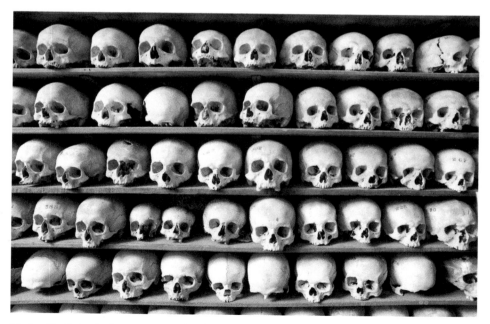

Hythe. Skulls in the former processional passage below the chancel. (Photo by Sir Paul Britton)

A memorial brass inscription to Sir Richard Clement must have been put into the church during his lifetime as his date of death was never filled in! In the north aisle is a wall tablet to Benjamin Harrison (d. 1921), a local shopkeeper and amateur archaeologist who made it his life's work to find and study prehistoric flint implements. More recently recognised as one of the pioneering experts in the field, he even has a flint tool incorporated into his memorial. Hidden behind the door is the memorial to Jane Lambarde (d. 1573), teenage wife of Kent's first historian, William Lambarde.

Outside the church it is interesting to see how the north aisle is entirely built of brick. After the Reformation brick was no longer despised for religious buildings. Nearby is the Bailey family grave, designed by one of the great Victorian Gothic architects, William Burges.

IVYCHURCH, ST GEORGE

Known for good reason as the 'Cathedral of the Marsh', this is one of the most rewarding churches in the county. Like all churches on Romney Marsh, it is built of ragstone brought from Mid Kent but is on a scale out of all proportion to its location or population. Whilst the present church dates from the fourteenth century, it replaced a slightly earlier church of some pretension – by the main altar you can see the exposed base of a thirteenth-century column. The medieval church was large because it was in the patronage of the Archbishop of Canterbury, and this mirrored his status.

The two-storey porch forms the entrance to the church. Its upper room, or parvise, was the strongroom for church valuables, whilst its benches on the ground floor would have been witness to many a legal transaction. It is only when you get inside that you realise the sheer scale of the church. Originally it was lit by a series of clerestory windows over both aisles but these have mostly been filled in as a result of storm damage over the centuries. Look how awkwardly the ones still in use sit under the roof beams – the weight of the roof has had to be brought down either side of the opening! In the south aisle a rough stone bench runs part way along the wall. This was the earliest form of seating in our churches and is the origin of the saying 'the weak go to the wall'. Whilst there is no chancel arch, the division between nave and chancel is well defined by the base of the former rood screen. When the screen was declared illegal in 1547 it was demolished by running a saw horizontally along the base of its muntins. The saw marks can still be seen. It would have looked very much like the contemporary screens that divide the chancel from its aisles. The base of the screen survives because it formed the back to the return stalls. Stalls were seats for clergy in the chancel, although here they were always just a status symbol, the church never having enough clergy to use them!

Rather a surprise is the fact that the north aisle is completely blocked off from the rest of the church, which is proof indeed that the building has always been too large. Now used for display purposes, it is full of interest and is entered via an eighteenth-century chinese Chippendale gate. The blocked east window still displays its tracery, and next to it are remains of a wall painting of exquisite beauty showing trailing vines in a fictive niche, only recently discovered and

conserved. The floor of the north aisle wasn't replaced by the Victorians, so is still of red brick, unevenly laid. Set into it are some old grave covers, including a stone thirteenth-century coffin lid. The huge royal arms are of the reign of George III and are dated 1775. The screen between nave and aisle contains some wonderful twentieth-century graffiti including portraits, poems and a builders' calculations for the lead roof. In history nothing is new and in the medieval period graffiti was actively encouraged and a pier in the south aisle is absolutely covered with initials, signs and inscriptions left by those too poor to be remembered in any other way. At the rear of the church is a Hudd, or wooden shelter that was taken to the graveside so that the parson conducting eighteenth-century funerals wouldn't get his wig wet!

KEMSING, ST MARY
The village is best known as the birthplace of St Edith (d. AD 984), daughter of King Edgar the Peaceful, who became a nun. Her Holy Well still bubbles at the road junction in the village centre. The chocolate-box parish church in a well-maintained churchyard stands a short distance away. The nave is possibly Saxon in date, remodelled in the twelfth century and again in the fourteenth century when the present roof was constructed. The chancel is also early but was reconstructed in the sixteenth century. A north aisle was added as part of a comprehensive restoration in 1890.

The character of the church derives almost entirely from this nineteenth- and twentieth-century beautification which saw it filled with high quality art. The rood screen is of the correct proportion and design to give a medieval appearance and in the main dates from 1894 with minimal amounts of old woodwork. The wonderful figures on top are of 1908 and were an early work of Sir Ninian Comper – the angels balance on their wheels like unicyclists! Comper also designed the wall paintings in the chancel, the altar, reredos and canopy. In the north aisle is an interesting collection of furnishings. There is a painted tile picture of Kemsing by the Kent artist Donald Maxwell, one of only a handful to survive. The central window is of two bishops and is typical of Comper's work, but it does not carry his usual signature of a strawberry plant.

The west window of the north aisle is by Douglas Strachan, 1935, and is an excellent example of his angular figures. By the font is a bronze Arts and Crafts panel of the Virgin and Child by Henry Wilson, the famous turn-of-the-century designer who lived in a neighbouring village and whose work may also be found in the churchyard. Fragmentary older glass may be seen throughout the church, but the best, a fifteenth-century depiction of St Anne, teaching Our Lady, is in the chancel which is normally inaccessible to visitors.

KILNDOWN, CHRIST CHURCH
The great restoration movement that saw most Anglican churches improved and enlarged in the nineteenth century had its origins here. Christ Church was built as an estate church by Viscount Beresford of Bedgebury Park in 1839. An uninspiring rectangular preaching box, typical of its date, it was soon to see

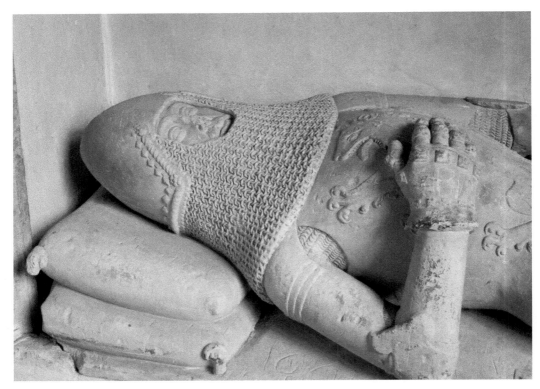

Ightham. Effigy of Sir Thomas Cawne, mid-fourteenth century. (Photo by John Vigar)

Ightham. Exterior from the south showing the sandstone typical of west Kent. (Photo by John Vigar)

Above: Ivychurch. Interior showing the octagonal piers of the south aisle which are typical of work of the fourteenth century. (Photo by John Salmon)

Right: Ivychurch. Royal arms of King George III, one of several fine sets on the Romney Marshes. (Photo by John Vigar)

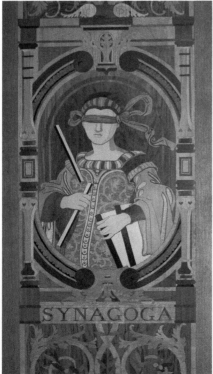

Above: Kilndown. Altar introduced by Alexander Beresford-Hope based on the tomb of William of Wykeham in Winchester Cathedral. (Photo by John Salmon)

Left: Kilndown. Synagoga. One of the outstanding inlaid wooden panels at the rear of the church. (Photo by John Salmon)

a metamorphosis into the glory we see today. The reason for such a change is that Lord Beresford's stepson, Alexander Beresford-Hope, was a prominent member of the Ecclesiological Society which was promoting the study of ancient Gothic churches. He realised that the newly built church fell far short of his medieval ideals and started to remodel it to rectify what he saw as its deficiencies. Outside he put a parapet around the base of the roof to make it seem less low-pitched. Inside he installed a rood screen designed by Carpenter and created a chancel of incredible richness. His altar was a copy of William of Wykeham's tomb in Winchester Cathedral and was technically illegal when it was installed as only wooden 'Holy Tables' were allowed in an Anglican church at that time.

The stained glass in the windows was by Mayer of Munich and depicts saints recognised by the Anglican church including King Charles the Martyr, King Edward the Confessor and the Venerable Bede. In the nave a theatrical pulpit was installed – jutting out from the wall and reached by a hidden staircase from the vestry. It was modelled on the thirteenth-century pulpit still to be seen at Beaulieu Abbey in Hampshire. The church became the talking point of its day and was seen as a turning point of the Gothic revival. Of later date are the amazing marquetry screens at the rear of the church presented by Beresford-Hope to Trinity College, Cambridge and later returned to the Bedgebury Estate.

LAMBERHURST, ST MARY

A pretty church with views into Sussex which stands on a steep hillside, meaning the east end is much higher than the west. Nave and chancel with a south chapel, south aisle and a west tower which is aligned with the aisle – which means that there is no west door. The chancel and chapel were rebuilt in 1870 by architect Ewan Christian, but he kept the fourteenth-century sedilia which stand between the two. They form a stone bench with two quatrefoil openings cut through the backrests, giving a view into the chapel. To the east there is a tall lancet opening for a piscina with a rectangular aumbry (cupboard) above.

The floor has been raised 3 feet 6 inches and the whole church interior reordered. The fine reredos in the south chapel is by Tinworth (1870), whilst the seventeenth-century pulpit carries the initials of the then rector, Robert Steede. It is a tremendous confection with backplate and canopy whilst the gryphons supporting the reading desk are particularly unusual. A good and rather theatrical royal arms of Queen Anne with billowing curtains and a crownpost roof complete the old furnishings, which were further enhanced in 1984 when a dramatic window of the angel appearing to the (very) startled shepherds was installed to the design of John Piper. Outside, in the south wall is a mass dial, an incised medieval sundial to tell the clergy when to begin the service.

LEYBOURNE, ST PETER AND ST PAUL

A simple village church that now serves a large modern housing estate, but whose history is of the greatest interest. Next to the church are the substantial remains of Leybourne Castle, still a private home. This was the seat of the eponymous family which played a major role in medieval court life. Sir Roger de Leybourne

(d. 1271) was a great supporter of the king, served as High Sheriff of Kent and Lieutenant of Gascony. Following his death his heart was buried in a shrine in this church. Fifteen years later this was visited by King Edward I who, with his wife, gave a pair of metal crowns to commemorate their visit. At that time the church tower was being built and someone had the bright idea to build these crowns into the wall, as we might lay a coin under a foundation stone today. There they remained hidden until the nineteenth century when the tower had to be rebuilt and the crowns came to light. They are on display in the church, as is Roger de Leybournes heart shrine which was similarly discovered (and opened) by the Victorians. It is certainly the finest of its type in Kent. Incidentally, only one of the stone caskets contained a heart, which must mean that his wife was buried elsewhere. Apart from these wonders the church is relatively simple but a small Norman window can be seen high on the south wall, and inside its deep splay are the remains of a simple vine trail wall painting of the thirteenth century. The tower is a complete refacing of its medieval predecessor and the contrast between the rubble construction of the church and the rock-faced Victorian tower is most striking.

LOWER HALSTOW, ST MARGARET

To my mind the North Kent Marshes are one of the undiscovered areas of the county known only to seafarers and birdwatchers, yet the many churches that flank its wilderness are witness to an ancient history. St Margaret's sits as close to the marshes as it could possibly be, the salty Medway Estuary washing its boundaries on two sides. The church sits down a public footpath with a handful of cottages for company, the rest of the village set back from the inlet.

This is a church of great antiquity – the name 'Halstow' means holy place and its stonework is of obvious Saxon origins, the south wall of the chancel incorporating herringbone masonry, built in part in reused Roman tile. The church hugs the ground, its tower set into the southwest corner of the aisle as if to offer some protection from the north wind. At the west end you can clearly see the vertical joins in the stonework where the north aisle and tower have been added on to the Saxon nave. Each aisle has a catslide roof, rather than its own separate roof structure, sweeping down to just a few feet from the churchyard. As it has aisles without clerestory windows the church is comparatively dark inside, the west window being the main source of light in the nave. Nearby is a great treasure – one of the few lead fonts to survive in the county. It carries a repeating design of King and Angel under a round-headed Romanesque arcade. At some stage in its history it was encased in plaster and only rediscovered after damage from shellfire immediately after the First World War. It lives, hidden from view, under an ogee wooden domed cover on a counterbalance. The narrow aisles were added to the original Saxon church in the thirteenth century, their pointed arches cutting through the original outer walls of the church. These flat surfaces must once have been covered in beautiful paintings, but sadly only a few traces remain, including St Peter and men in a boat. On the south arcade there is a particularly fine graffito of a Persian beast with the head of a man, body of a lion, mane of quills and sting of a scorpion!

Lamberhurst. Mass dial to determine the time of Mass on the south wall. (Photo by John Salmon)

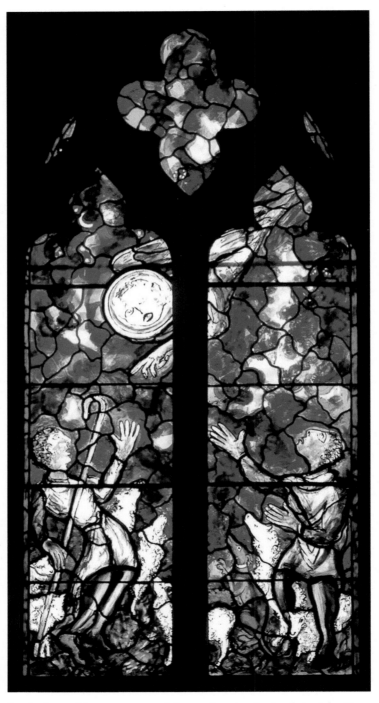

Lamberhurst. The appearance of the angel to the shepherds by John Piper.
(Photo by John Salmon)

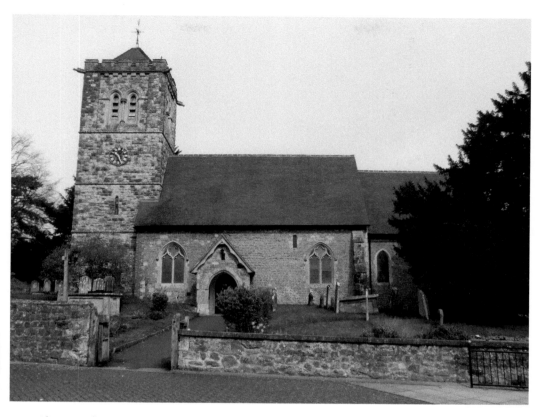

Above: Leybourne. In this view it is easy to see the
difference in texture between the Norman nave
and the rock-faced ashlar of the nineteenth-century
tower. (Photo by John Vigar)

Right: Leybourne. The Heart Shrine of Sir Thomas
de Leybourne (d. 1271). (Photo by John Vigar)

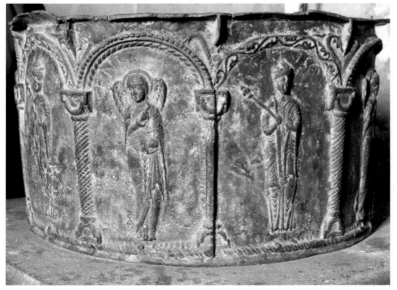

Above: Lower Halstow. The catslide roof which covers both nave and aisle helps shelter the church in its exposed location on the Medway Estuary. (Photo by John Salmon)

Left: Lower Halstow. Medieval lead font of a repeating design of kings and angels normally hidden under its wooden cover. (Photo by John Salmon)

The east window was designed by A. L. Moore and Son and shows Christ Appearing to a First World War soldier. Variations on this theme may be found in churches countrywide, but this is a particularly fine example with the White Horse of Kent and Invicta motto in the tracery. The chancel walls north and south have what appear to be blocked arches, which you might suppose once led into side chapels, but as can be seen from the walls outside, these arches never opened through the walls. They were just for decoration, to make the chancel more elaborate – a feature not uncommon in the churches of north Kent.

LULLINGSTONE, ST BOTOLPH

Many people see this little dolls' house of a church on the sweeping lawn of Lullingstone Castle and assume it's a private chapel, but in fact it's the parish church and open daily. As one would expect with a building so closely linked to the castle it is a treasure trove of family history. From the south eighteenth-century alterations made to the two-cell Norman church may be clearly seen. The walls were raised to accommodate an elaborate plaster ceiling, and a south porch was added. The blocked-up window to the south of the chancel marks where a large tomb had been installed, and an internal window in the north chancel wall once let in light before the addition of the north chapel to the chancel to take the tomb of Sir John Peche (d. 1522) which lies under an arch between chancel and chapel. Sir John was also responsible for building the rood screen, which contains carvings of peach stones as a rebus (or pun) on his name. This screen was further embellished in the eighteenth century when the classical wooden balustrade was added to the top.

There are further monuments of note. On the south side of the chancel, and responsible for the blocked window outside, is the large monument to Sir Percyvall Hart (d. 1581). This shows Percyvall and his wife lying on a true sarcophagus under a barely Gothic entablature, the introduction of classical forms now almost *de rigeur*; whilst in the north chapel is the splendid chest tomb of Sir George Hart (d. 1587) complete with a charming standing skeleton reminding us of mortality. In complete contrast is the Gothic wall panel opposite commemorating his descendant Percyvall Hart (d. 1738) who was the man responsible for the works noted outside. His memorial describes him as 'the munificent repairer and beautifier of this church'. In a south window is a rare stained-glass sundial of seventeenth-century date. These often contain a little joke, and sure enough, just below the sun, is a painted fly, looking as if it is just warming itself!

At the back of the church and almost forgotten amongst the larger treasures is a tiny font enclosed in a tall wooden case. As a point of interest, just a few hundred yards away are the remains of the Roman Villa that provides evidence of Christian worship in Kent before the arrival of St Augustine, so this valley represents the continuity of the faith like no other part of the county.

LYDD, ALL SAINTS

Whilst most of the Romney Marshes were reclaimed from the sea in the late medieval period, there were already some islands just off the coastline, and Lydd

was one such, proven by the existence here of a church probably 400 years earlier than all the others in the area. It is a matter of conjecture as to just how early the surviving Saxon remains are at Lydd, but they bear great similarity to the seventh-century Kent churches at Canterbury and Reculver. At Lydd the Saxon work is to be seen at the west end of the north aisle, near the font, and takes the form of tall and austere ragstone arches, which originally opened to a narrow aisle. They may not be works of art, but they are hugely important archaeologically.

The church grew in several building campaigns but is now mainly a thirteenth-century church with a very late and tall west tower dated from documentary sources to the 1440s. The whole church is nearly 200 feet in length, reminding us that it served a wealthy town which was an important member of the Cinque Ports Confederation. Unfortunately, the church was bombed in the Second World War and the chancel is a complete rebuilding. Controversially at the time it was rebuilt in thirteenth-century form, and not as it was immediately before the bomb. In hindsight this has created a harmonious interior and continues the thirteenth-century simplicity from end to end.

The original arcades of the nave display circular piers, broken only once by a fourteenth-century rebuilding where they meet the transepts when they are octagonal in form. The east window contains extraordinary stained glass of 1958 by Leonard Walker full of swirls and smoky glass. There are a good number of monuments. The earliest is to be found in the north chapel and is of a cross-legged knight of thirteenth-century date. There is a plethora of brasses, some now mounted on the wall for protection. My favourite monument is to Thomas Godfrey (d. 1623), the bright colours still shining out and highlighting his incredibly blue eyes. Unfortunately, the letter cutter forgot to include his surname, which then had to be inserted rather awkwardly above the first line!

Under the tower is an early nineteenth-century memorial signed by the famous sculptor John Flaxman, which shows the infant Henry Russell being passed from earth to heaven by an angel. But above all my memories of Lydd will always be of little medieval smiling faces. These are found on the arch covering the medieval effigy, and on the label stops of the nave. Whoever carved them must have been of a happy disposition.

MAIDSTONE, ALL SAINTS

Standing a little away from the commercial centre of the town, down by the river, this is one of the widest churches in Kent, dating from the late fourteenth century when it was granted a College of Canons – the buildings of which still stand nearby, as does the former Archbishops Palace. The tower, which stands to the south of the nave, originally had a tall spire, but this was struck by lightning in 1730 and not replaced. The breathtaking scale of the interior – an aisled nave of six bays, chancel and chapels – is somewhat compromised by the severe wooden roofs inserted by John Loughborough Pearson who restored the church in 1886. A good set of Victorian stained glass includes work by Clayton and Bell (1890), Wailes (1861) and Capronnier (1872). The twenty stalls have excellent misericords, mostly showing coats of arms of those associated with the college.

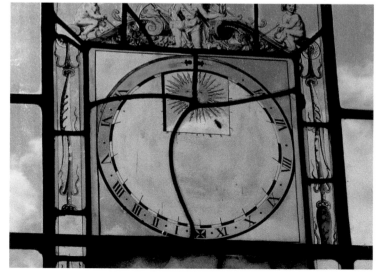

Above: Lullingstone. A two-cell Norman church that has been much altered and which stands on the lawn of Lullingstone Castle. (Photo by John Vigar)

Right: Lullingstone. A rare seventeenth-century stained-glass sundial which contains a painted fly near the sun. (Photo by John Vigar)

Above: Lydd. Interior looking east. The chancel was rebuilt following damage in the Second World War. (Photo by John Salmon)

Left: Lydd. Post-war stained glass by Leonard Walker. (Photo by John Vigar)

Maidstone, All Saints. Shroud monument to John Astley (d. 1641). (Photo by John Salmon)

Maidstone, All Saints. Medieval painting on the Wotton tomb. (Photo by John Salmon)

Archbishop William Courtenay (d. 1396) is possibly buried in the chancel, and a brass indent to him survives. Set into the fine sedilia is the tomb of John Wotton (d. 1417), the first master of the college. It incorporates a painting of Wotton being presented to Our Lady. Nearby is graffiti associated with the game of noughts and crosses! There are many other monuments including one to John Astley (d. 1641) by London sculptor William Wright. Although rather compromised by being pushed into a confined space it depicts two men and two women in their shrouds. Astley was Master of the Revels to King James I and King Charles I. There is also a memorial to Sir Charles Booth (d. 1795) signed by Nollekens, and a tablet to Lt Col Shadwell who was murdered by a deserter in the village of Wrotham in 1799. In the atmospheric churchyard is the chest tomb of William Shipley who founded the Royal Society of Arts.

MARGATE, ST JOHN THE BAPTIST

Long before the Isle of Thanet became Kent's seaside hotspot Margate was a prosperous inland farming community. This is mirrored in the magnificent church that shows the location of the medieval village. Originally all the island's churches were chapels to Minster, but gradually each gained parochial status and independence. What a large church this is – Nine bays in length and completely of the Norman period with no structural division between nave and chancel. The 'cut through' appearance of the arches of the arcade reinforce the solidity of the

building, though the aisles have been widened with their own roof structures, and some of the piers renewed in the fourteenth century. The font is rather battered but incorporates the arms of the Cinque Ports Confederation, Margate being added as a limb port to Dover in the fifteenth century, an event probably marked by the commissioning of this font.

The church contains a better than average collection of monuments including a fine thirteenth-century chamfered stone coffin lid. Brasses abound, and of special note is that to Thomas Smith (d. 1433) showing a heart with three radiating ribbons. Of similar date is Nicholas Canteys (d. 1431), complete with bushy beard and little short socks standing on a grassy hillock. Richard Notfelde (d. 1446) is depicted as a grinning skeleton. There are plenty of other monuments. That to Paul Cleybrooke and his wife (d. 1624) depicts the couple in alabaster in an act of prayer, but unusually has a helm on top of the family crest. This feature was becoming less common at this period as fewer people wore armour, and funeral processions were using hatchments, not helms, as a status symbol of the deceased. Margate has twenty good examples of these, now hung against the roof. The most interesting is that to Sir Thomas Staines (d. 1830). It incorporates two oval shields for Thomas and his wife Sarah Bargrave. The right-hand white background tells us that his wife survived him, but as his honours were so many his shield takes up more of the hatchment than usual, and the white background has had to be reduced from half to a third! The three pendant badges are for the Order of the Bath, the Royal Sicilian Order and of the Imperial Ottoman Order. His motto *Virtute ad Astra* roughly translates as 'those who are virtuous reach the stars'. By the eighteenth century Margate was well established as a health resort, so many people came here for the benefit of sea air and water, never to return. This accounts for the myriad of memorials on the aisle walls that refer to places outside the area.

MEREWORTH, ST LAWRENCE

One of the few eighteenth-century churches in Kent, this church was built in 1746 by the 7th Earl of Westmoreland. The medieval church it replaced was in the park of Mereworth Castle, but an expansion of that house necessitated its demolition and replacement on the current site. Surprisingly for so late a date the name of the architect is not known, although it is in the style of Colen Campbell who designed the castle, but as he had died in 1722 it will be by one of his followers. The main external feature of the church is a tall stone spire with four urns at the top of its tower, whilst the body of the church is a plain rectangular box consisting of a (narrowly) aisled nave and chancel.

Inside is an excellent display of eighteenth-century interior decoration – especially important being the curved ceiling which is painted with *trompe l'oeil* coffered panels. The pillars are painted to resemble marble, although the eagle-eyed will notice that the bases are of a different design. This is because the church was originally fitted with box pews that would have hidden the bottom few feet from view. When the pews were taken out it was obviously hard to match the original marbling! At the west end is the galleried pew belonging to the owners of Mereworth Castle – it has fictive organ pipes painted on its rear wall. The stained glass in the tripartite lunette at the east end is heraldic glass brought here from the

old Mereworth Castle when it was demolished. Beneath it the Victorians removed the central board of the reredos (now in the north aisle) and inserted a round-headed window which was filled with stained glass in 1875.

Also of Victorian date is the excellent Raising of Lazarus window, installed in 1889 by the firm of Heaton, Butler and Bayne. The south-west chapel contains memorials brought here from the old church, including one to a fifteenth-century Lord Bergavenny, and Sir Thomas Fane (d. 1589). The latter monument has a superb top-knot! Most unusually the monument to the 5th Lord Bergavenny (d. 1535) has a flat shelf as if it was designed as an Easter Sepulchre, but instead it displays a heart held by a pair of naïve hands. Below is his shield of arms, beautifully carved and surrounded by the motto of the Knights of the Garter. In the churchyard, due south of the church, is the grave of Charles Lucas (1834–1914), the first man to be awarded the Victoria Cross, granted for service aboard HMS *Hecla* during the Crimean War.

MINSTER IN SHEPPEY, THE ABBEY CHURCH OF ST MARY AND ST SEXBURGA

The name 'Minster' takes us back to the earliest days of Christianity. It can be found all over England and means 'a mother church' and here in Kent we have two places of the same name, both on islands. This church was founded as a monastery in AD 664 by Queen Sexburga, widow of Erconbert, King of Kent. She became its first Abbess before moving to Ely which had been founded by her sister Etheldreda. Remarkably, a major portion of Sexburga's church survives as the north aisle of the present church. The monastery was destroyed by the Danes and re-founded by William the Conqueror.

In the thirteenth century the present parish church was built attached to the south side of the monastic church, the arcade between the two being filled by a wooden screen. In 1536 the monastery was closed, and the property passed to Sir Thomas Cheyne whose monument dominates the church today. The monastic buildings – apart from the magnificent gatehouse, now a museum – were demolished, and both churches became one. For such a complicated history today's church is remarkably simple, consisting of the parish church and north aisle which formed the monastic church.

The church is entered by a fine Norman doorway which must have once been in the earlier building as it now sits in a thirteenth-century wall. It leads to a large wider church on whose walls hang eighteenth-century 'Godly Texts'. These are certainly less run-of-the-mill than usual with such injunctions as 'Husbands, love your wives'. The stonework of the east window has rere-arches, to create a three-dimensional appearance, and beside them are two niches. The southernmost contains the remains of a wall painting of St Nicholas who is commonly associated with seafarers. What better place to find him than in an island church that is visible from the River Swale far to the south, and open sea to the north? In the south wall of the nave is an enigmatic monument, reputed to be Sir Robert de Shurland (d. 1325). He lies under a (later) multi-cusped arch, turned to his side, his head resting on a helm. Stories abound as

to why there is the head of a horse at his feet, and in the nineteenth century the antiquary the Revd Richard Barham wrote his 'Ingoldsby Legends' about the carving which he said represented a horse called 'Grey Dolphin'. In more recent times the historian Professor Nigel Saul has suggested that it represents his War Horse, and as a prominent English soldier who took part in wars against Scotland under Edward I, this seems more than likely. In the north wall of the monastic church is an alabaster effigy of William Cheyne (d. 1487) whose wife was Isabella Boleyn. For some reason it has been deliberately vandalised. His son, Thomas Cheyne (d. 1559), sports the finest monument in the church, now between the chapel and chancel, although it was originally in its own private chapel. A protegee of Cardinal Wolsey, later favoured by Henry VIII, Cheyne did well for himself and was rewarded with the position of Lord Warden of the Cinque Ports and a Knight of the Order of the Garter. At the Dissolution of the Monasteries he purchased Minster Abbey (and others besides). His effigy, complete with forked beard, sports his Garter Chain and shields of arms of all those important families to whom he was related. Like other monuments in the church it is rather battered.

By the nineteenth century Minster church was almost a ruin and a campaign was launched to restore the well-kept building we see today. One of the donors was Queen Victoria herself, no doubt aware of the earlier royal links with the building.

Margate. Interior looking east showing the circular piers of the Norman church and fifteenth-century font. (Photo by John Salmon)

Above: Margate. Royal arms of King George III. (Photo by John Salmon)

Opposite above: Minster in Sheppey. Monument to Sir Robert de Shurland showing the horse's skull at his feet. (Photo by Sir Paul Britton)

Above: Minster in Sheppey. Exterior from
the east. To the left is the chancel with
its three lancet windows, to the right the
seventh-century monastic church. (Photo
by Sir Paul Britton)

Right: Minster in Thanet. Medieval
engraved inscription on one of the bases of
the chancel wall arcading. (Photo by John
Salmon)

Minster in Thanet, St Mary

The history of this Minster is of two sites. The first site is that of the monastery founded in AD 669 by Domneva, great-granddaughter of King Ethelbert. This is just to the north-east of the present church and is still home to a monastic community. This foundation established the Christian credentials of the area and soon led to the formation of a community to service the monastery whose members needed their own church, the predecessor of St Mary's. Today we find a church on an extraordinary scale, as befits a manor which was by that time in the ownership of St Augustine's Abbey, Canterbury. It is built using local flint, Kentish ragstone and imported Caen stone from Normandy. The huge west tower, surmounted by a spire, is twelfth century, as is most of the nave. However, the story is rather more complex, as you will see from inside the aisles where it is obvious that part of the nave reused an existing wall, with blocked windows still visible in it. Perhaps this section is late Saxon or of an earlier Norman construction. The transepts and chancel are, in any case, a rebuild of the thirteenth century, again on an unprecedented scale. Yet even here things are not straightforward. The stone vaulting of the chancel is Victorian, for the planned vaulting was never completed, possibly because St Augustine's Abbey diverted funds elsewhere. This is by no means a criticism of the present work, which is wonderful, but just to explain how complex an outwardly simple building can be.

The greatest treasures in the church are a set of eighteen misericords. These are tip-up seats in the chancel that in this case acted as a status symbol, but which, in other churches, would have been used by a community of monks or canons. They are dated by an inscription on one by the vestry door to John Curtis, vicar here between 1401 and 1419. Each is worthy of inspection but my favourite is on the end at the north side and shows the popular old English rhyme 'Jack, Jack the goose has gone' with, in the centre, the housewife doing her spinning whilst on the right her husband shouts out whilst on the left a fox runs away with their dinner! On the base of the thirteenth-century vault arcading is a superbly lettered medieval inscription recording the burial of Mr Trotman nearby, a reminder that few could afford proper memorials in the medieval period. The church also contains a fine modern sculpture of Our Lady and Child by Mother Concordia, late Abbess of Minster Abbey.

Nettlestead, St Mary

Despite the busy A26 thundering just a few yards away, this always feels like the least visited Kent church and I have yet to meet anybody else there on my many visits. This hidden gem owes its existence to the medieval Nettlestead Place next door, the owners of which have been associated with it for centuries. The oldest part of the church is the tower, dating from the thirteenth century. This is now attached to a church completely rebuilt in the first half of the fifteenth century by the Pympe family, great supporters of the Woodville family and tenants of the Dukes of Buckingham. The reason why everyone should visit the church is to see the glass they installed in the huge Perpendicular windows which march down the nave. The shield of arms of the Pympe family

may be seen, as well as those of their overlords and other families with whom they were associated. Reginald Pympe (1448–1530) was a threat to the Crown during the brief reign of Richard III but he lived to enjoy happy times in the reign of Henry VII.

The church is of simple design – just west tower, nave and chancel – and it has a feeling of greater age. The six enormous windows that Reginald Pympe installed in the church in the 1420s make the interior feel rather like a greenhouse. There is little wall at all between them, and where there is its only purpose is to support buttresses outside. In the chancel a little donor figure in blue kneels at the feet of St Laurence, and this may well be Reginald himself, asking for prayers from future generations. Sadly, glass on the south side was destroyed in a storm in the eighteenth century, and what images were broken at the Reformation were skilfully restored and augmented by the stained-glass artists Ward and Hughes in the early twentieth century. So clever is their work in mimicking the surviving medieval glass that the window at the north-east corner of the nave had to be labelled 'this is all new' to tell future generations that it was a re-creation.

There are two lovely monuments on the east wall of the nave – to Katherine and Elizabeth Scott. These were the two wives of Sir John Scott (d. 1616). Elizabeth, whose monument is on the north side of the chancel arch, was born a Stafford, the Buckingham overlords of the Pympe family from whom Sir John Scott was descended. She was distantly related to Anne Boleyn and became a Lady of the Bedchamber to Queen Elizabeth I, after growing up in Switzerland as a Protestant exile during the reign of Queen Mary Tudor. Within six months of her death Sir John had married Katherine Smythe, daughter of Thomas Smythe, Treasurer of the Virginia Company in which Scott was also an early investor. Whilst both these wives were buried at Nettlestead, John Scott was buried at his family church at Brabourne in east Kent. The two monuments bear close comparison. Both show the women kneeling at a prayer desk and are surmounted by a shield of arms. However, Katherine's also has a kneeling figure behind her, one of her sons by her first husband. This monument was conserved in 2012 and looks splendid.

NEW ROMNEY, ST NICHOLAS

Until 1287 New Romney was a major seaport located at the far end of the Rhee Wall, which bisected the marshes and linked mainland Kent to an island. As such it was a member of the Cinque Ports Confederation and a major political player. Its merchants and councillors were wealthy, its people well connected. In 1287 a tremendous storm caused the River Rother to change course. The port was lost, and New Romney became an inland town. However, it remained a major political player, returning two members to Parliament until the Reform Act of 1832. All this is mirrored in its magnificent church, which originally stood on the harbourside, and which was in the patronage of the Archbishop of Canterbury.

The first thing to be noticed is how much the ground level around the church has risen – in large part this happened during the storm of 1287, when shingle

was thrown up from the sea. The church is built of ragstone with dressings of Caen stone and is a building of two distinct periods. The tower and nave are Norman whilst the east end dates from an enlargement of the late thirteenth century. The west end of the nave is the earliest period, followed shortly afterwards by the addition of the huge west tower, the top of which is thirteenth century. This Norman work is influenced by the contemporary work at Canterbury Cathedral and is both strong and impressive. The great west door may have been in the original west wall of the church and moved when the tower was built. Under the tower you can still see the west front of the original church inside. The piers of the nave change from circular to octagonal, marking the later rebuilding and extension. Blocked arches high in the walls were originally a clerestory, bringing light into the church before the aisles were widened and heightened as part of the later rebuilding. This was undertaken after the patronage of the church had passed from the archbishops to the abbey of Pontigny in France, and acted both as a status symbol and as a stage for more elaborate ritual. Best seen from outside is the series of easternmost windows. These are in a very particular style of Gothic architecture known as 'reticulated' and date from around 1300.

The church retains many furnishings of note. Most prominent are the box pews in the nave which luckily survived the period in which many were being thrown

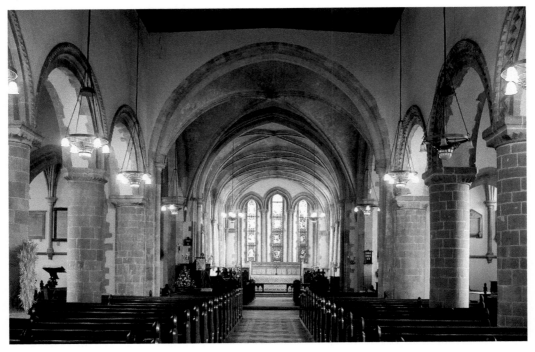

Minster in Thanet. Interior looking east down the Norman nave, through the crossing into the thirteenth-century chancel. (Photo by John Salmon)

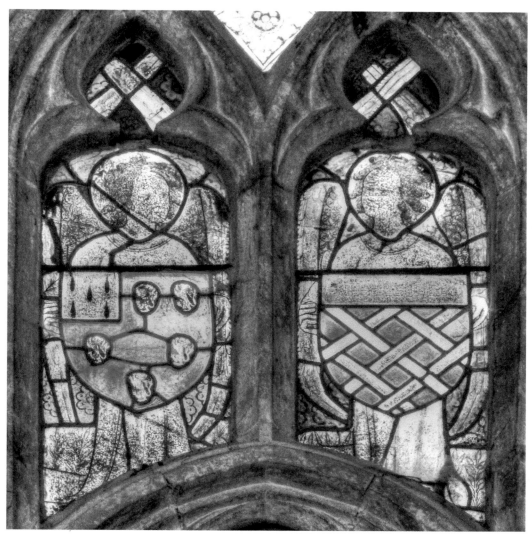

Nettlestead. Heraldic glass recalling donors from the fourteenth century. (Photo by John Vigar)

out. At the east end the three chapels have plain sedilia, or seats for the clergy at Mass, and multiple aumbries – cupboards for the storage of valuable liturgical items. The floors are delightfully uneven and contain many ledger slabs and medieval tiles, especially at the east end. My favourite ledgerstone commemorates Charles Cobb who was 'killed by a Cannon Shot in action with the French' in 1811, and there is another to Edward Goulstone who 'resolved into ashes' in 1666. Like many churches on the Romney Marshes there is a fine royal arms, this one for Queen Anne and dated 1704. There are also two painted boards of the Furnesse family, major benefactors to this church in the eighteenth century. In the

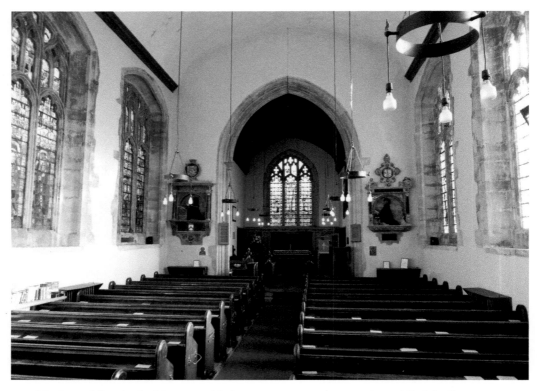

Nettlestead. Interior looking east with the monuments to the two wives of Sir John Scott either side of the chancel arch. (Photo by John Vigar)

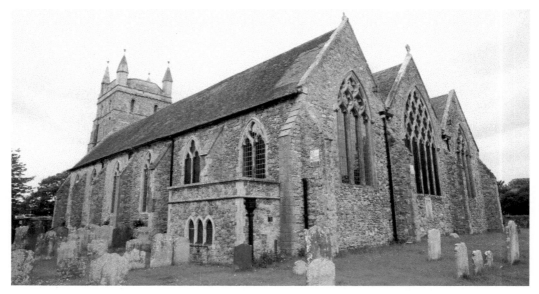

New Romney. Exterior from the southeast. (Photo by Ian Hadingham)

Offham. Interior looking east showing the faint outline of the earlier and wider chancel arch of the original twelfth-century church. (Photo by Sir Paul Britton)

Offham. Vertical archaeology showing the building lifts which represent each period of construction and two original windows (one blocked) in the north wall. (Photo by John Vigar)

north wall is a fine gabled recess with a bold thirteenth-century stone coffin lid on the floor in front of it.

OFFHAM, ST MICHAEL

One of the smaller Kent churches, set apart from its village next to a busy farm, it displays one of the very best examples of 'vertical archaeology' in its north wall. Early churches were built by the local population whose free time was dependent upon the agricultural year. Only twice in the year was there a little spare time for church construction – a handful of weeks in the spring and again in the early autumn. Therefore, only a few feet of walling could be built in one go. Here at Offham the horizontal layers marking each season's work can be clearly seen in the north wall of the nave. In the lower levels the ragstone and sandstone rubble is occasionally laid in herringbone pattern, a sign in Kent of work just before the Norman Conquest. Higher up the wall this pattern disappears and incorporates two Norman windows, one still used, the other blocked when it was replaced by a larger window in the fourteenth century. So, here is a wall that gives us many

clues to its origins either side of 1066. Whilst it is clear to see today it would not have originally been seen as it would have been covered by layers of limewash to protect the wall from the weather.

There is more evidence of the Norman origins of this church inside. The blocked window seen outside is now much more prominent, but dominating the nave is the former round-headed chancel arch. In the thirteenth century the original chancel was demolished and replaced by a much larger construction, together with a north tower, and the opportunity was taken to fill in the wide chancel arch and replace it with the more fashionable narrower, pointed arch we see today. The chancel work was never finished – look at the arch to the tower, which is uncut stone rather than the dressed stone normally found. Opposite, high in the window is a delightful piece of medieval glass (take binoculars) of St John the Evangelist, the little Devil in his 'poisoned chalice' looking all the world like a little dog! The unusual stonework of this window shows that it was enlarged by the insertion of a completely new window at a lower level (with the donors' shields of arms in its glass) in the fourteenth century. In the centre of the chancel is a ledgerstone made of contrasting black and white marble. The inscription, complete with the letter cutter's mistake, makes a charming read.

SANDWICH, ST CLEMENT

Sandwich is the best-preserved medieval town in Kent, its tightly packed streets, gateways and ramparts drawing countless visitors a year. It boasts three surviving parish churches, each of which is worth visiting. Two are retired but very active in their new incarnations as venues, whilst St Clement's is now the parish church. Unfortunately, it is the least visible of the three churches and the visitor will need to seek it out. This church has at its core a Saxon building, which can be appreciated outside as vertical joins in the west wall, and inside as a scar of the original roofline above the present crossing arch.

The Normans substantially rebuilt and enlarged this church. Of their work the noble central tower with Caen stone facing and the fantastically carved capitals of the crossing arches are the outstanding features. The font dates from the early years of the fifteenth century and carries the shield of arms of the Cinque Ports. In the chancel a fine set of stalls with misericords sits on a platform with circular holes in its base. These are called 'sound holes' and would originally have contained jars that acted as primitive amplifiers. If you look up in the walls either side of the altar you can see other sound holes too. There are several piscinae in the church, each one showing the site of a former altar, by far the most unusual having a drain in the form of a lion's head, rather than the more usual plain hole. Stained glass in the east window by the little-known London designer, Pepper, is outstanding. It depicts the patron saint St Clement flanked by St Peter and St Paul and looks almost Byzantine in its simplicity. The other two town churches were the fashionable places in which to be buried, so there are no grand monuments here, but lots of details to search

out. I particularly like the main north doors of the porch, with studs showing the date 1655 and the initials RR and WH, the churchwardens who installed them.

SHIPBOURNE, ST GILES

An expensive nineteenth-century church, paid for by Edward Cazalet of the Fairlawne Estate at a cost of over £15,000. The architects were the little-known Mann and Saunders and in many ways this is an urban church in a delightful village setting. The exterior is of rock-faced construction, uncommon in Kent (although see the tower at Leybourne). I don't find the exterior particularly successful – it seems rather mechanical and the horizontal banding of dressed stone gives an alien effect. Yet it is the interior that the visitor comes to see. Here the walls are entirely covered in sgraffito decoration. This is formed by applying different layers of coloured plasters and then cutting through each overlaying layer to show the chosen colour underneath. Designs can be figurative, but here at Shipbourne they are purely decorative.

At the west end of the church is an unusual arrangement of canopied seats for the churchwardens in a heavy Gothic style that seems rather at odds with the rest of the interior. There were at least two previous churches on this site and locked in the vestry is a small amount of surviving medieval stonework. Also surviving from the previous church is a wonderful monument to Lord

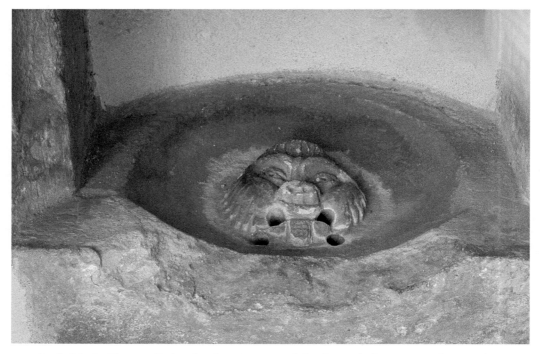

Sandwich, St Clement. Piscina for the priest to wash his fingers before Mass with a rare lion head drain. (Photo by John Salmon)

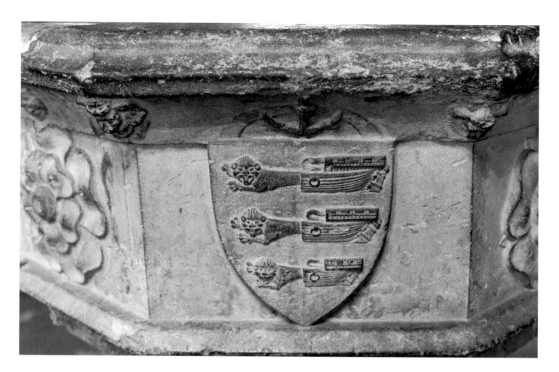

Above: Sandwich, St Clement. Fifteenth-century font showing the arms of the Cinque Ports displayed on one face. (Photo by Ian Hadingham)

Right: Shipbourne. Sgraffito decoration on the walls by Mayer of Munich. (Photo by Sir Paul Britton)

Shipbourne. Lord Barnard monument, 1723, by James Gibbs. (Photo by Sir Paul Britton)

St Margaret at Cliffe, exterior from the southwest showing the huge early Norman tower. (Photo by John Salmon)

St Margaret at Cliffe. Window commissioned to remember three parishioners killed in the *Herald of Free Enterprise* disaster in 1987. (Photo by John Salmon)

Barnard (d. 1723) by James Gibbs. Recently cleaned, it shows Barnard, his wife and daughter with a large urn and entablature. The glass in the east window, like the sgraffito decoration, is by Mayer of Munich, a firm which excelled under the patronage of the Bavarian royal family and which established a London office in 1865 to meet the demand for church furnishing. Living off their royal credentials meant rich pickings and this is one of their finest English interiors. The church contains a Battlefield Cross which marked the grave of Edward Cazalet who was killed at the Battle of Ginchy in September 1916, and there is also a fine bronze plaque to his memory showing him at school and at study.

ST MARGARET AT CLIFFE, ST MARGARET

High on the White Cliffs of Dover is an extraordinary Norman church. Almost hidden from its busy village street, this is one of the most famous churches of its date in the county built of local flint with Caen stone dressings. Noble in its proportions and decoration, it may be one of the earliest aisled churches anywhere. In most Norman parish church buildings the aisles have been added onto a pre-existing structure, but it appears here that they were conceived as a piece when the church was rebuilt under the patronage of Dover Priory in the early twelfth century. The clerestory windows are set, outside, into a continuous arcade of arches, some subdivided, others plain. They are all blind except those lighting the clerestory. The arcades have most unusual decoration, and some corbels above them suggest that perhaps a different form of roof was intended. The piers themselves have alternate designs. Every other one is circular, whilst the rest are composite. This creates an architectural problem as the capitals of each type must be different, the composite piers requiring extra elaboration. Where the decoration on each arch meets the pier is a charming grotesque head to scare away evil spirits. My favourite part of the church is the chancel – long and impressive with dignified not-yet lancets in the east wall. In the south aisle is a window commemorating three local men who lost their lives in the *Herald of Free Enterprise* disaster in 1987 with the Kent Invicta symbol in prominent position. The very plain font is dated 1663 and must be a replacement for a medieval font ejected during the Commonwealth when basins were the only acceptable form of container for baptism.

STONE NEXT DARTFORD, ST MARY

If a church ever deserved to be surprised it is this one. Once standing alone on a high ridge, supporting an agricultural community, its tower a prominent landmark on the River Thames, it quickly had to face the building of a railway, the disappearance of its fields into a quarry and the arrival of thousands of new homes. Yet, despite everything around it changing, St Mary's survives as one of the outstanding examples of thirteenth-century architecture in England. The outside view is unusual in that the chancel is much taller than the nave,

in fact almost as tall as the tower! This shows that the east end is a work of some magnificence as will be seen inside. The church was in the patronage of the Bishops of Rochester who had a house here at the midway point between Rochester and London and their connections in royal circles no doubt helped the rebuilding of this church. This is particularly noticeable in the use of building materials which include Reigate stone and Purbeck marble, both of which came from royal quarries and were being used to build Westminster Abbey at the time. We can imagine boats destined for London stopping here and offloading materials, and the travel wasn't just one way, for it is obvious from the architecture that masons working at Westminster came down here to supervise the work.

The first thing the visitor notices are the clustered piers of grey Reigate stone and black Purbeck marble shafts. The capitals are deeply carved and the arcade arches richly moulded. The aisles themselves are very narrow with lean-to roofs and were never intended to take fixed seating as we see today. Now to the chancel, which we know from outside is going to be a knockout. The walls are covered in blank arcading with detached shafts and deep carving in the spandrels. Interestingly the arcading doesn't start at the chancel arch, meaning that the designers planned to have stalls on either side of the chancel where the nineteenth-century ones stand today. The extreme height of the chancel outside is now explained as it is stone vaulted, the current vault a nineteenth-century replacement, as is the east window with its kaleidoscopic stained glass by William Wailes (1860).

As built the church would have been full of wall paintings, but sadly only a few traces remain, including a martyrdom of Becket. Once we have appreciated the architecture, we can notice the details. There is an unusual brass to John Lumbarde (d. 1408) with a ribbon text issuing from his mouth and a biblical inscription surrounding him in an octofoil. If it wasn't damaged this would be one of the finest of its type in England. Also in the floor are the covers of the *Mitchells Hypocaust* heating system installed by the Victorians, now a rarity. Of all the memorials in the church the most interesting is to a young soldier, twenty-three-year-old Henry King, who, having survived conflicts at Sebastopol, Alma, Balaclava and Inkerman, was drowned whilst bathing in Malta in 1857.

TROTTISCLIFFE, ST PETER AND ST PAUL

This picturesque village is pronounced 'Trosley' and its characterful church stands a mile to the east of the village in a lower fold of the Downs. The large farm next door was originally a summer palace of the Bishops of Rochester used to escape the urban stench of the medieval city. For such a small church there is much of interest. Unusually it is entered underneath the tower, built on the south side of the nave as there was no room to add it at the west end as the church was already up to the boundary of the palace. The west wall of the church is a Victorian rebuild, made entirely of graded knapped flints. This is where the flints have been cut in half and squared and then used in the wall with the largest at the bottom. In a region of England where this type of work was

rare even in the medieval period, such exuberance is unexpected. Further round the church you'll find the use of tufa, always an indication that you're looking at a Norman building. It looks a little like a bath sponge and was popular with the Norman builders. On the north side of the church, under a yew tree, is the grave of Graham Sutherland, the twentieth-century artist best known for designing the tapestry at Coventry Cathedral and for his infamous portrait of Winston Churchill.

Inside, the gargantuan pulpit came from Westminster Abbey in 1820 and completely dominates the interior. Designed by Henry Keene in the late 1700s, it was thrown out to make room for the coronation of George IV. The sounding board is carried up like a palm tree, a symbol of power. The altar rails are eighteenth century and just to the left of the main central gate is a most unusual feature, an offertory box for the churching of women. There is a good selection of stained glass for such a small church – ranging from large fifteenth-century canopy work in the tracery of the north window, through Ward and Hughes' glass of 1885 in the west window, to Comper-style glass in the south wall and a late twentieth-century window by Kent artists Keith and Judy Hill depicting Bishop Gundulf who lived in the neighbouring palace in the twelfth century.

Stone next Dartford. Interior looking east. (Photo by John Salmon)

Stone next Dartford. Mitchells Patent Reverberating Smoke Consuming Hypocaust for the Warming of Churches. (Photo by John Salmon)

Trottiscliffe. Exterior showing the unusual location of the tower, which also forms a south porch. (Photo by Ian Hadingham)

Trottiscliffe. Interior showing the pulpit which was originally built for Westminster Abbey. (Photo by John Salmon)

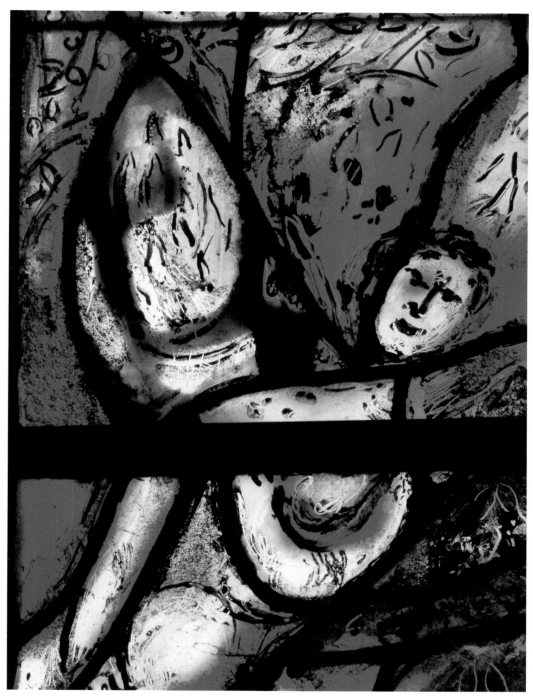

Tudeley. Angel in glass by Marc Chagall. (Photo by John Vigar)

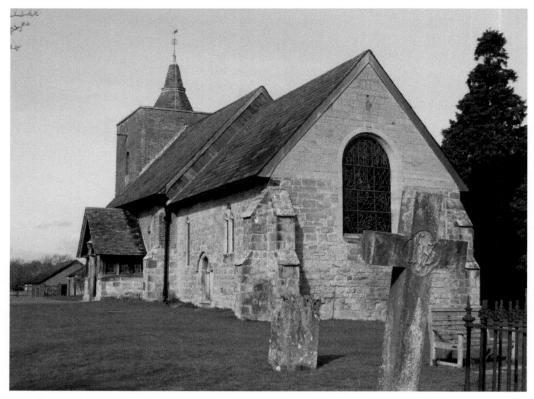

Tudeley. Sandstone exterior from the east. (Photo by John Salmon)

TUDELEY, ALL SAINTS

When the historian Edward Hasted visited Tudeley in the eighteenth century he was not too complimentary about it. Like many rural Anglican churches, it had been poorly maintained and when he visited it had just been rebuilt in simple form. Yet 200 years later it has become a much-loved treasure house of twentieth-century art. The story starts with the accidental death of Sarah d'Avigdor-Goldsmith in 1963. Her parents commemorated her life by a new window in the church designed by the internationally acclaimed artist Marc Chagall, whose work Sarah had admired in Paris shortly before her death. When Chagall attended the installation of his window he expressed an interest in designing more for the church and under the patronage of the family produced a full set that was installed over the next thirty years, although a lengthy local dispute meant that Chagall never saw them all in situ. This is the only church in the world to have a complete set of Chagall glass. As soon as we enter the church it is his work that dominates. On the south side where the sun is bright the colours are predominantly yellow whilst on the north aide they are in blue. Unusually for Chagall's work the windows here are at eye level, allowing us to see the details, and it takes some time to get used to his unique style. He

was inspired by Psalm 8, which is all about the world around us and the later windows are full of animals and birds, whilst the original east window shows the Crucifixion. There is good interpretation in the church to help you get the most from your visit.

Whilst the glass brings most visitors there are other things to see. In the north wall of the chancel is an Elizabethan monument to George Fane (d. 1571), Sheriff of Kent, a very fine classical composition of tomb chest, three Ionic columns and a pediment with his shield of arms. In the floor is a small brass depicting his ancestors, Thomas and Marion Stidulf (d. 1457), who lived at Badsell Manor.

TUNBRIDGE WELLS, KING CHARLES THE MARTYR

Early visitors to the spa at what was to become Tunbridge Wells were forced to attend church in either Tonbridge or Speldhurst churches, both some miles off, and it was inevitable that an increased population would demand a more convenient church. In the pavement outside is a boundary marker, showing how close to the junction of the parishes this chapel was. It was built in 1676 as a chapel in the parish of Speldhurst and did not become a parish church until 1889. Externally it appears to be a simple brick box, but this belies three major incarnations. Originally it was half the size and faced north-south, 90 degrees to its current orientation. Within a few years it was doubled in size with the magnificent plaster ceiling to be seen today, installed by one of Sir Christopher Wren's top plasterers.

In 1882 a small chancel was added, and the interior turned around to more suit nineteenth-century sensitivities, making the various plaster ceilings look as though they don't fit together. The early twentieth-century font is an interesting classical design in white marble, whilst the chancel woodwork came from one of Wren's demolished City of London churches, All Hallows, Bread Street. The galleries were originally for the poor and were accessed directly from outside, but by the nineteenth century they had become the fashionable seats, even being used by the future Queen Victoria on her visits.

ULCOMBE, ALL SAINTS

This is a lovely church, full of atmosphere. There is much plain glass which makes for a light and impressive interior. In the south aisle there are a surprising number of medieval wall paintings, especially fine being those of St Michael, the Crucifixion and the Last Supper. In the sanctuary, on the north wall, is a superb drawing – which was never painted – showing five priests. The south chapel has a good set of decorated windows with reticulated tracery. There are several image brackets. The north chapel contains some excellent monuments, including three tomb chests, one of which commemorates William Maydeston (d. 1419), though the finest brass is to Radulph St Leger (d. 1470) in amazing armour! The arch from the north chapel to the nave has on its underside some thirteenth-century chevron painting and an entrance to the rood loft stairway. In the chancel are some medieval stalls with five misericords, showing two dragons and a lion-like creature.

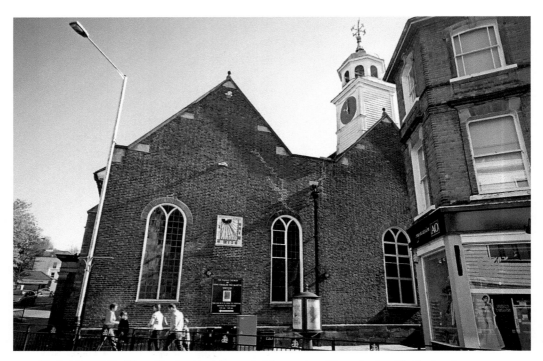

Tunbridge Wells, King Charles the Martyr. Brick exterior. (Photo by Ian Hadingham)

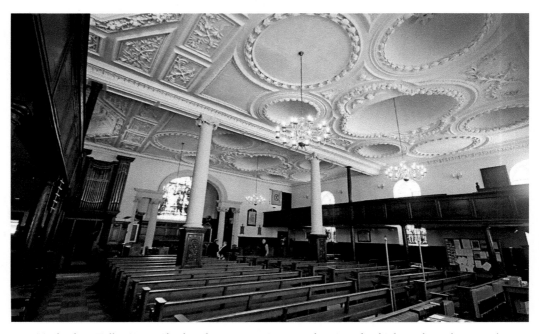

Tunbridge Wells, King Charles the Martyr. Interior showing the high-quality plasterwork ceilings for which the church is known. (Photo by Ian Hadingham)

Ulcombe. The
St Leger brass of
1470. (Photo by
John Vigar)

Ulcombe. Medieval
wall paintings.
(Photo by John
Vigar)

WEST PECKHAM, ST DUNSTAN

West Peckham village is at the end of a dead-end road and this little-visited place offers a most interesting church originally of Saxo-Norman origin, with an early double-splayed window on the south face of the tower. The church is small, dark and welcoming, dating in the greater part from the fourteenth century. The north chapel contains the private pew of the Geary family. When the burial vault beneath became full the floor of the pew was raised by 8 feet to provide more burial space, creating a solid-floored galleried pew! It is panelled and benched and appears to be of expensive construction, although closer inspection reveals that it is made of cheap wood grained and painted to look like oak! On the ceiling of the pew is a good collection of hatchments, and the top of the earlier monuments, lost when the floor was raised, may still be seen. Behind the altar is a series of continental wooden statues representing the Twelve Apostles which were a twentieth-century gift from Mereworth Castle. The chancel screen is also twentieth century in date, and although it is a good example of craftsmanship, it is patently the wrong size – its loft is far too high for the medieval door opening that still survives in the north wall!

WEST STOURMOUTH, ALL SAINTS

Two things strike one as unusual. Firstly, that this really was at the mouth of the River Stour when the Wansum Channel separated Kent and Thanet, and secondly that in 1851 the two Sunday services here were attended by over 120 parishioners. It is such an out-of-the-way place that time has stood still, and the church is now enjoying its retirement.

West Stourmouth. Amateur glass by the early nineteenth-century incumbent. (Photo by John Salmon)

West Stourmouth. Interior looking east. (Photo by John Salmon)

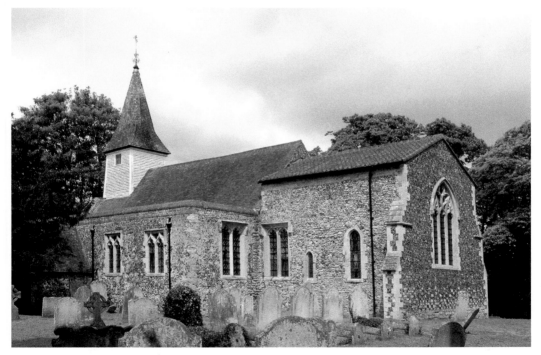

West Stourmouth. Exterior. (Photo by John Salmon)

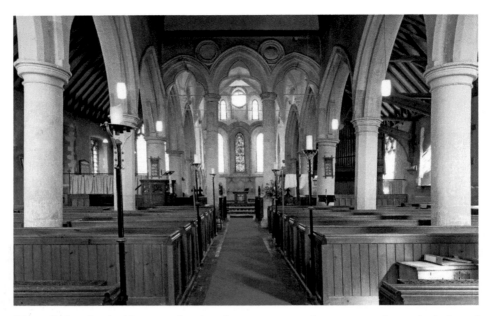

Westwell. Interior looking east showing the stone screen that supports the vaulted chancel ceiling. (Photo by John Salmon)

Westwell. Unicorn bench end, fifteenth century. (Photo by John Vigar)

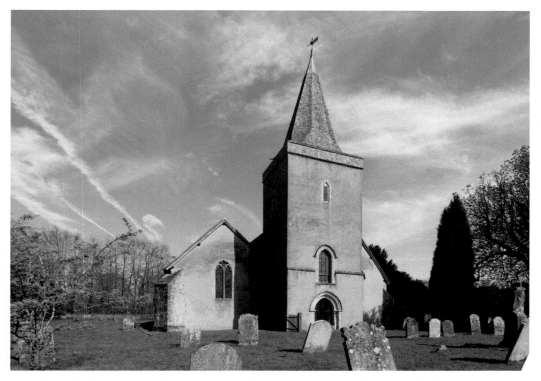

Westwell. Exterior from the west showing the rendered exterior. (Photo by John Salmon)

What a varied collection of furnishings this church offers the visitor. At the rear of the church the stalls have early nineteenth-century decorative ends made of papier mache! On the north wall of the nave is a monument to Carr Culmer. You might think from the inscription that he had made it to the grand age of 100, but sadly the calendar changed in his lifetime and as we lost eleven days in the process, he just missed out! The very colourful glass in the south aisle is amateur stained glass made by the then rector, Mr Drake. I think we can agree he wasn't much of an artist, but glass of this period is rare, especially when made at home in an amateur kiln.

WESTWELL, ST MARY

Don't be put off by the unpromising rendered exterior for here is one of the best churches in Mid Kent. It's particularly rewarding because throughout the Middle Ages it belonged to Christ Church, Canterbury, which spent large sums of money on it. The chancel, by far the most elaborate part of the building, is separated from the nave by a stone screen of three trefoil-headed arches supported on very tall cylindrical pillars. That this was not the rood screen may be seen by the notches cut into it that originally carried the wooden screen set at a lower level in between. The chancel is vaulted in stone, held together today by essential iron tie-bars. The sedilia, of three seats, set under battlements,

are unusual in having the two easternmost seats on the same level, with just the third a few inches lower. The east window contains some medieval glass depicting the Tree of Jesse, while in the north chapel is some heraldic glass of Richard II's reign. Don't miss the unicorn on one of the medieval bench ends, or the ritual protection graffiti on the arcades. In 1967 two flagons were sold to the Goldsmiths' Company to raise money for essential repairs to save this church from total collapse.

WROTHAM, ST GEORGE

In an excellent position overlooking the diminutive village square, the church is much larger than one imagines, no doubt due to the influence of the Archbishop's Palace that formerly stood next door. The south chapel shows the rood loft staircase leading to the top of the fourteenth-century screen and its colourful altar was designed by Sir Ninian Comper in 1907, whilst the stonework of the main east window was inserted in 1958 and came from Wren's St Alban's Church in London, damaged in the Second World War.

By far the best visual feature in Wrotham church is the chunky nineteenth-century stone and marble pulpit designed by Newman and Billing in 1861, whilst in front of it is a series of memorial brasses showing the changes in

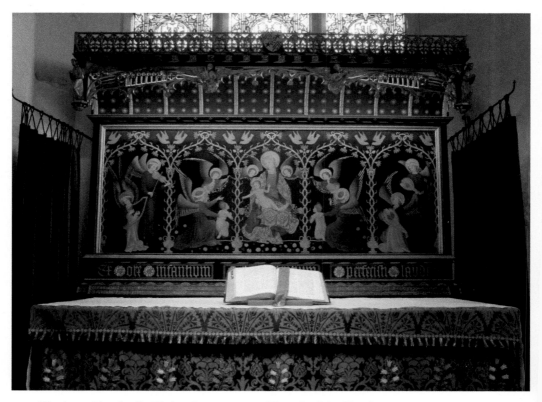

Wrotham. Altar by Sir Ninian Comper, 1907. (Photo by John Vigar)

style that took place over three centuries. The tower has an unusual feature – a vaulted passage leading right under it from north to south at ground level to allow medieval processions to circumnavigate the building. Its walls are deeply scored with marks which we used to think were where people sharpened their swords but now believe that these are the results of people scraping tiny grains of sand which they believed had healing properties, to add to food for the sick.

Wrotham. Marks left by people taking grains of stone for religious use. (Photo by John Vigar)